FRINTON & WALTON

THROUGH TIME

Michael Rouse

AMBERLEY PUBLISHING

For my aunts, Hilda 'Pip' Cooper and Polly Unwin,
two lifelong tennis players who both graced the courts at Frinton
and the memory of those who played with them

M. H. R.

First published 2013

Amberley Publishing
The Hill, Stroud, Gloucestershire, GL5 4EP
www.amberley-books.com

Copyright © Michael Rouse, 2013

The right of Michael Rouse to be identified as the
Author of this work has been asserted in accordance with
the Copyrights, Designs and Patents Act 1988.

ISBN 978 1 4456 1505 9 (print)
ISBN 978 1 4456 1514 1 (ebook)

British Library Cataloguing in Publication Data.
A catalogue record for this book is available from the
British Library.

Typesetting by Amberley Publishing.
Printed in Great Britain.

Introduction

Frinton and Walton on the 'Sunshine Coast' are close neighbours separated by different visions and attitudes, but linked by wonderful beaches, a gently shelving seabed and miles of beach huts.

From the outset, in late Victorian times when seaside resorts like Southend and Clacton were developing along the Essex coast, Richard Powell Cooper (1847–1913) was determined that Frinton would not follow the pattern set by Peter Schuyler Bruff for Clacton and Walton but become 'a high class and select watering place'. Cooper was a veterinary surgeon who inherited the family business of William Cooper & Nephews, which developed the first effective sheep dip. He was remarkably successful at home and abroad and became a baronet in 1905 for services to industry.

Cooper's Frinton would have golf, tennis, fine hotels, a magnificent clifftop Greensward, but there would be no public houses, fish and chip shops, beachside ice cream sellers or amusement arcades. This was to be a place for the fashionable and retired. The vulgar day trippers could go to its noisy neighbour Walton, arriving by steamer and enjoy their fish and chips and amusements there.

This part of the coast has fought a long battle over the years with the sea and both Frinton and Walton have lost many buildings. The vast sea defences needed to protect the crumbling cliffs have provided a magnificent promenade, giving access to the miles of beach and providing a platform above the sea for beach huts as far as the eye can see.

Select Frinton famously developed inside the railway gates on a classic triangular grid of avenues leading down the sea. When Network Rail wanted to replace the iconic gates with modern barriers there was local uproar and protest as it was felt that they symbolised Frinton's unique character and Network Rail was forced to replace them during the night of 18 April 2009.

Frinton is still different, although it is possible to buy fish and chips inside the gates now. Nearly all the great hotels have been replaced by blocks of apartments, some like Frinton Court of staggering 1960s insensitivity, but that was seen as progress then by the local council if not by many of the residents.

Walton did not have a single controlling figure, there were several. John Penrice wanted to create Walton around his Marine Hotel and small pier, and then Peter Bruff had a rival scheme to the south with his Clifton Hotel and new pier. Later, the iron founder John Warner created East Terrace and tried to pull Walton in that direction, while finally Philip Brannon tried to develop Naze Park even further east. All this gives Walton a certain charming incoherence.

More people may come to Walton for a traditional week's holiday because of the caravan parks, while Frinton might be more sustainable because it is less reliant on holiday trade. In essence, both are now places by the sea for commuters and the retired that really become busy when the sunny weather brings the day trippers in their thousands to enjoy some of the finest beaches on the coast.

This volume charts something of the rise and fall of the holiday industry in the two towns. All my photographs were taken in late June and July of this year in a summer heatwave when the sand looked glorious and the sea looked inviting and the beach huts were serving their purpose.

<div align="right">

Michael Rouse
Ely, 2013

</div>

Acknowledgements

I have looked at the original research I did for my book *Coastal Resorts of East Anglia* (Terence Dalton, 1982). I have referred to *Frinton and Walton, A Pictorial History* by Norman Jacobs (Phillimore, 1995); *Walton-on-the-Naze in Old Picture Postcards*, Bernard J. Norman (European Libraries 1984); the Walton-on-the-Naze History Trail leaflet and various websites.

I am particularly grateful to Jan Benmore at the Rock Hotel and restaurant in Frinton-on-Sea for information, Sally Johnson at Caxton Books in Frinton-on-Sea, Maria Elkin, Bar and Events Manager at Frinton Lawn Tennis Club, and Pat Batley for supplying the lovely early photograph of tennis at the club.

Special thanks to my younger son, Lee, for accompanying me on two of the trips, for being in some of the photographs and for looking after me, especially when we climbed to the top of the Naze Tower.

Finally, thanks again to Joe Pettican and all at Amberley for giving me the chance to discover again the charms of these Essex neighbours.

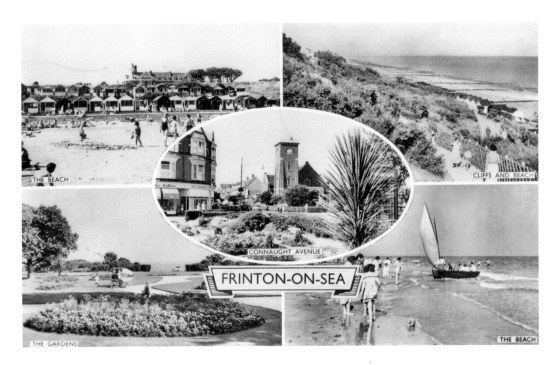

Frinton-on-Sea, c. 1955
'We have come here for the day just on our own and have had picnic lunch on sands. Beautiful sunny day. We have to keep moving, the tide coming in. Shall have tea in the town.'

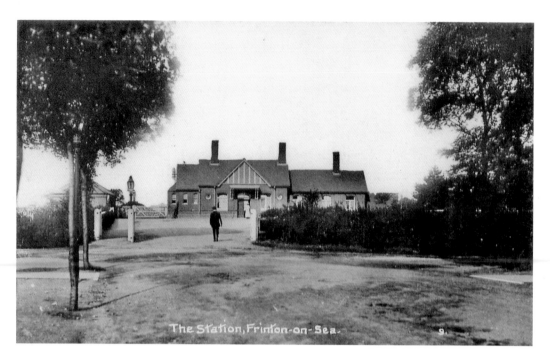

The Station, Frinton-on-Sea, *c.* 1910

Frinton was an old but very small village on a part of the Essex coast that was under constant attack from the sea, which was nibbling away at the cliffs. In 1881, the population stood at fifty-five. It was the age of the railway and though the line to Walton ran through the village there was no station. In 1888, Frinton got its railway station on the Colchester to Walton line, but the new town was slow to develop.

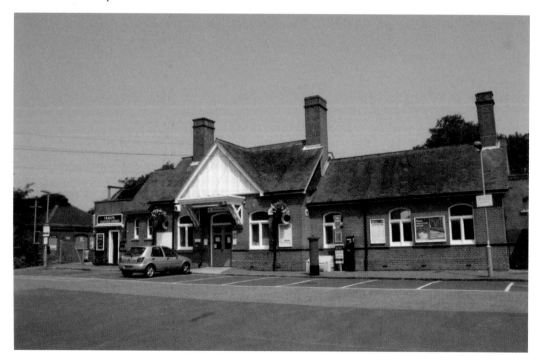

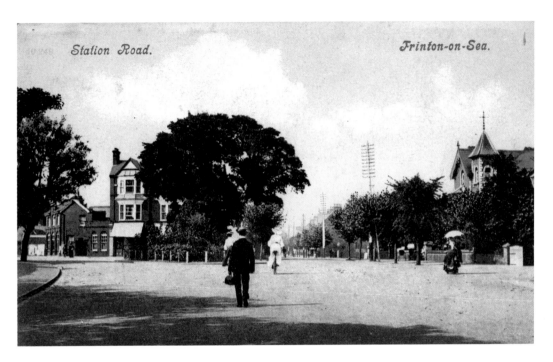

Station Road. Frinton-on-Sea.

Station Road, Frinton-on-Sea, *c.* 1906
The year 1871 had seen the first August Bank Holiday and all around the coast developers were active. In 1885 the Marine & General Land Company bought up most of the available land and announced its plans for a new resort with 'broad terraces, squares, crescents, tree-lined avenues and roads'. By 1891 the population had only grown to eighty-seven. The man who brought the railway to Walton and did so much to develop that town and now had plans for Frinton was Peter Schuyler Bruff (1812–1900), the engineer for the Eastern Counties Railway and a very forward-thinking Victorian entrepreneur.

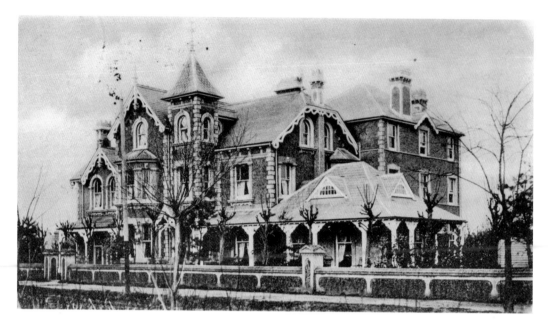

Ocean View, Frinton-on-Sea, *c.* 1903

Development brought some grand Victorian houses. Ocean View can just be seen on the right on the view before at the end of Station Road. The message is intriguing: 'This is our house where we are living, my mother is still at Weeley, Grandfather don't like her coming away.' Then added in pen is: 'I have got my sister living with me now.' By the 1920s Ocean View was known as The White House Hotel. Today the building has gone and been replaced by apartments; the little garden below is almost opposite.

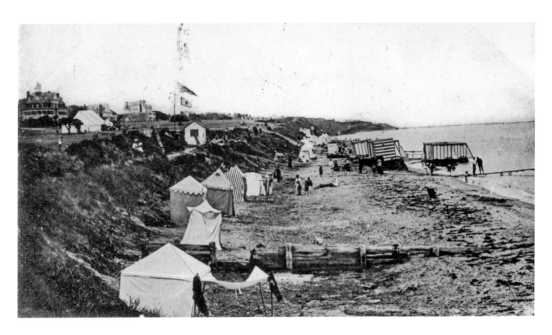

The Beach, Frinton-on-Sea, *c.* 1904

It was Peter Bruff who solved the reason for Frinton's slow growth, which was the lack of a good water supply, by finding a source at Mistley, forming the Tendring Hundred Water Company and piping water to the new resort in 1888. He had a vision for creating Frinton Haven but in 1893 the man arrived who would really control the way Frinton developed. That man was Sir Richard Powell Cooper (1847–1913). Cooper bought an interest in the bulk of potential development land. He owned most of the Greensward and seafront and his Frinton would be different.

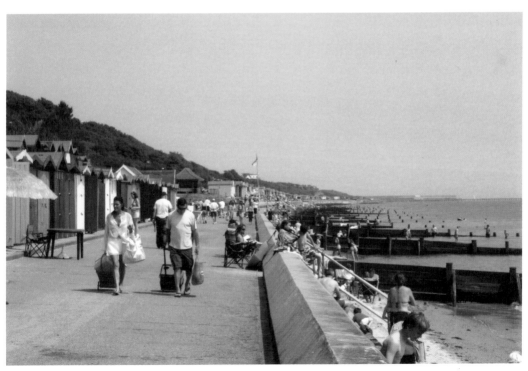

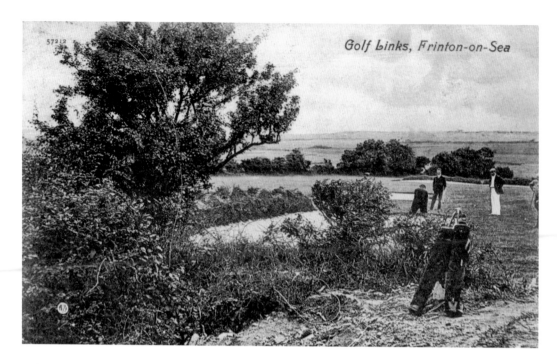

Golf Links, Frinton-on-Sea, *c.* 1905

Golf was a huge attraction for the classier and more select resorts and in 1895 Richard Powell Cooper opened a nine-hole golf course where Second and Third Avenues are today. In 1904, Willie Park Jnr designed the eighteen-hole links course along the clifftops to the south of the town. Apart from being requisitioned by the Army during the Second World War and mined to hamper invasion, the course, which reopened in 1947, has maintained its reputation as one of the finest in the country.

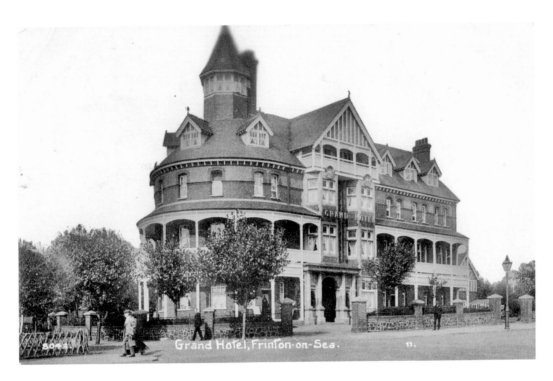

Grand Hotel, Frinton-on-Sea, *c.* 1912

Golfers need somewhere to stay and in 1896 Cooper opened the beautiful Grand Hotel on the Esplanade close to the original course and only a short walk from the new golf course. The Grand looked out on the Greensward that Cooper created at the top of the cliffs, giving a wide-open green space before the Esplanade.

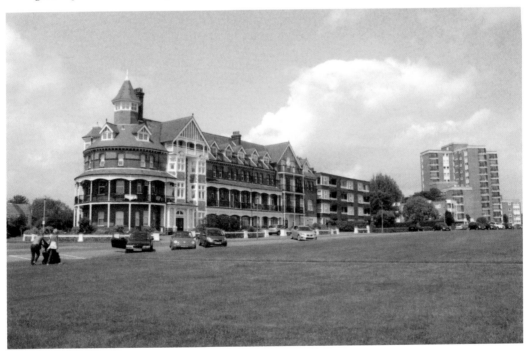

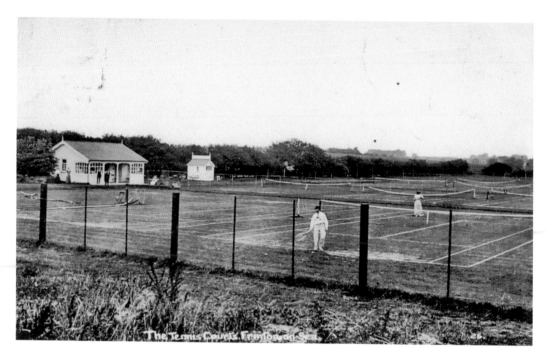

The Tennis Courts, Frinton-on-Sea, *c.* 1912

In 1899, Frinton Lawn Tennis Club was founded by Cooper. The original club also offered members bowls and croquet, but it was for the tennis and still is that the club became one of the most prestigious venues in the tennis calendar. Wimbledon champions played here and, from the young and aspiring to the old and perspiring, Frinton Lawn Tennis Club was and still is one of the great places to play.

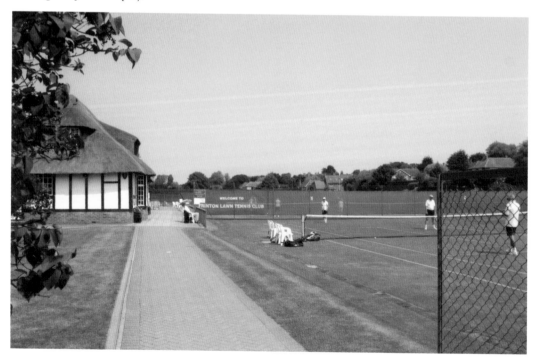

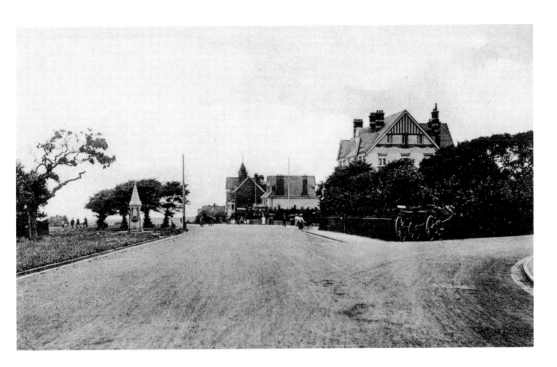

Esplanade and Jubilee Fountain, c. 1906

The Jubilee drinking fountain, commemorating the Coronation of King Edward VII, was erected in 1902 by the residents of Frinton. It stood opposite the Jubilee Gardens at the end of Connaught Avenue. In the 1960s, when new public conveniences were constructed nearby on the Greensward, it was removed and sadly lost. In 2000, through the efforts of the Frinton Environmental Action Committee, which were generously supported locally, a replacement was erected in the Jubilee Gardens.

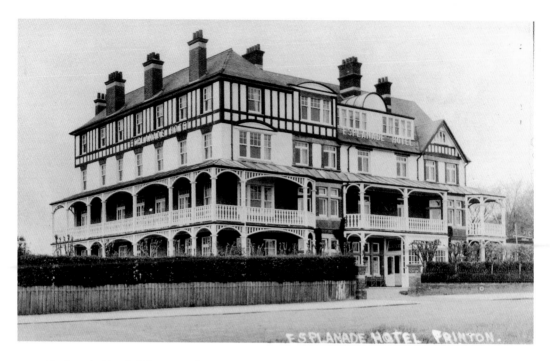

Esplanade Hotel, Frinton-on-Sea, *c.* 1910

We proved the fountain works in its fine new setting, just opposite from where the Esplanade Hotel stood. The magnificent Esplanade Hotel was built in 1902 at the seaward end of Connaught Avenue, arguably the finest location on the seafront. Its telephone number was 5! This and the other fine hotels that were built along the Esplanade demonstrate how the holiday trade was developing and how confident businesses were in the future of seaside resorts.

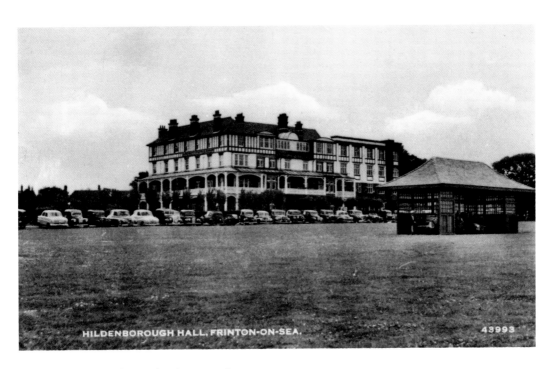

HILDENBOROUGH HALL, FRINTON-ON-SEA.

43993

Hildenborough Hotel, Frinton-on-Sea, *c.* 1950

In 1960, the former Esplanade Hotel, which had become the Hildenborough Hotel, was demolished. It was the first of the major hotels to be lost through the decline in the holiday trade. The local council hailed Frinton Court, the eleven-storey block of apartments granted planning permission to replace it, as welcome progress. Hoteliers condemned it as the beginning of the end of Frinton as everyone knew it in the first half of the century and many residents hated it.

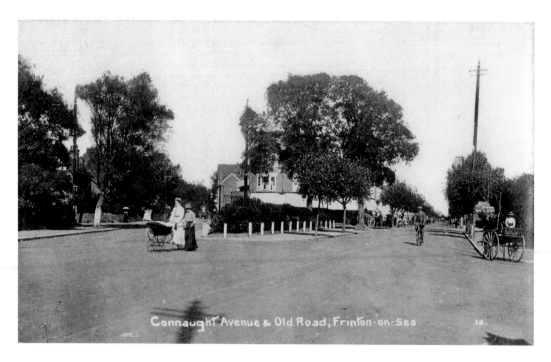

Connaught Avenue and Old Road, Frinton-on-Sea, *c.* 1912

That glimpse of the future was unimaginable in this unhurried photograph of the pram being pushed across the road, the horse and cart and the lone cyclist. The Free Church seen below on the right was built in 1912. Station Road became Connaught Avenue following the visit in 1904 of the Duke of Connaught, Queen Victoria's seventh child and third son, in 1904. He was the Inspector General of the Forces and came to umpire Army manoeuvres, staying at the Grand Hotel. As a result of his visit the prosaic Station Road was renamed Connaught Avenue, which is much more Frinton!

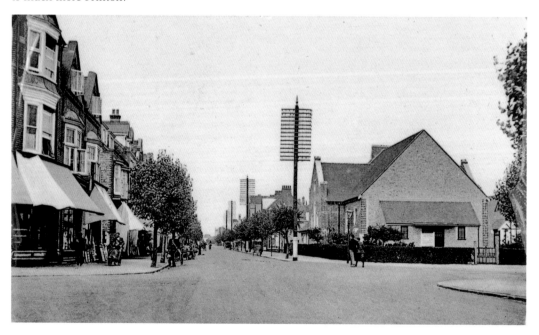

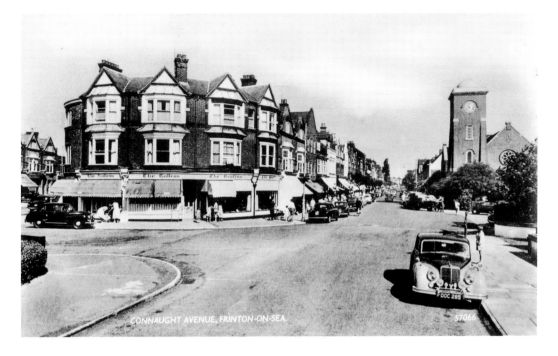

Connaught Avenue, Frinton-on-Sea, 1950s

In 1935, the tower was added to the Free Church and Connaught Avenue had developed into one of the finest shopping streets along the coast. It was known as the 'Bond Street of East Anglia' because of the quality of the shops. By the time of this photograph, the motor car is prominent. Today, the Grafton is the Star of India restaurant and there is still a good lively shopping street with many independent traders.

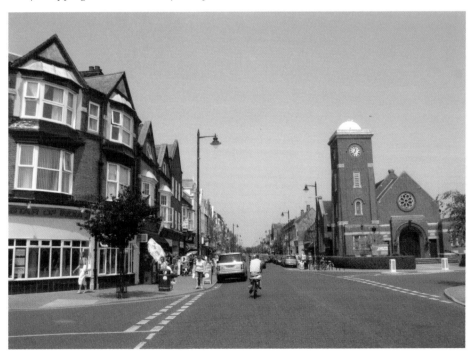

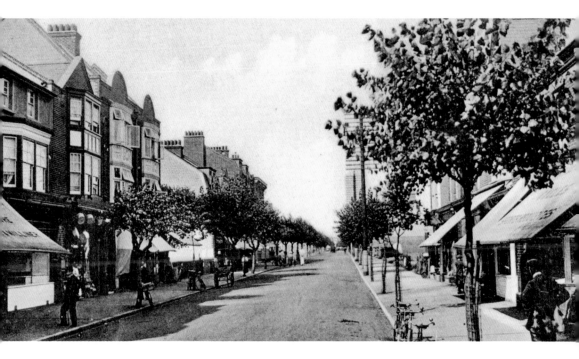

Connaught Avenue, Frinton-on-Sea, c. 1914

Frinton used to boast of having no public house but in September 2000 the Lock and Barrel opened. Posted on 20 September 1914, the message from Elizabeth back to her friend Rose in St John's Wood in London reminds us of what was happening far from this unhurried street scene: 'Many thanks for letter. I have wondered if your brother has gone to the front yet. I expect you are very busy. I am longing for our return.'

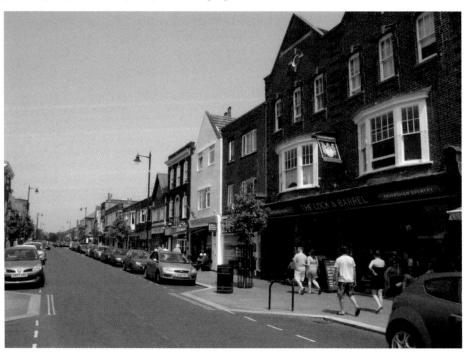

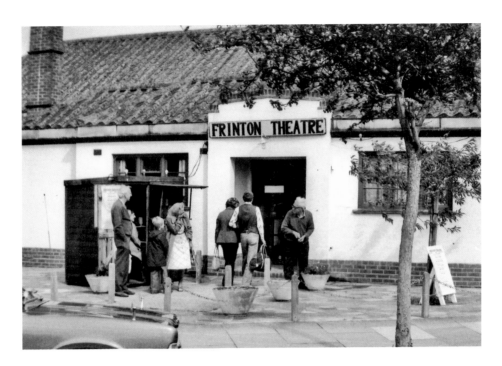

Frinton Summer Theatre, *c.* 1980

The Summer Theatre at Frinton – seven plays in seven weeks – celebrates its seventy-fifth birthday next year. Since 1947 it has taken over the McGrigor Hall in Fourth Avenue for the season. Facing closure in the early 1970s, it was saved by the well-known actor Jack Watling for the 1974 season and he and his family continued to run it for many years. MTP productions now run the theatre, which has over the years become a summer institution and a great training ground for young actors.

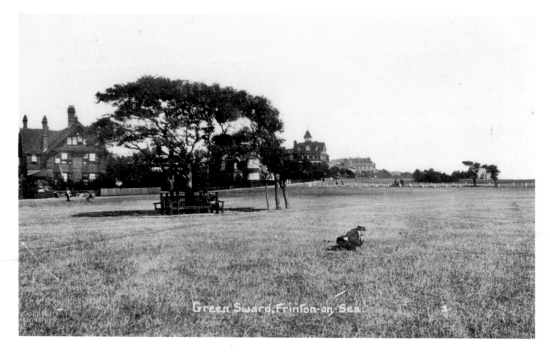

Greensward, Frinton-on-Sea, *c.* 1912

The famous Greensward was laid out in the early years of the twentieth century as part of the extensive sea defence works in 1903 that created nearly a mile of sea wall, promenade and groynes to protect the soft cliffs from being eroded by the power of the sea. By 1911 the population had climbed to 1,510 and Frinton had already established a reputation as a select resort and not one that relied on the trippers.

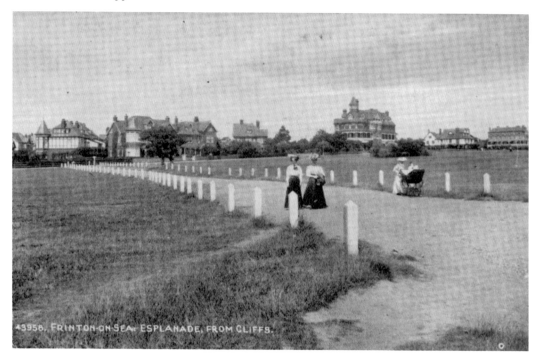

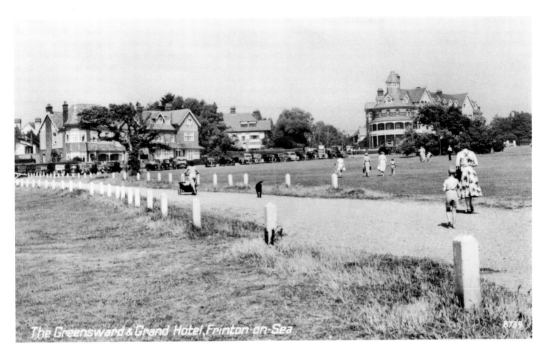

The Greensward and Grand Hotel, *c.* 1950
The Greensward was, of course, a sensible precaution if the cliffs continued to be eaten away, but it also became the defining feature of the town.

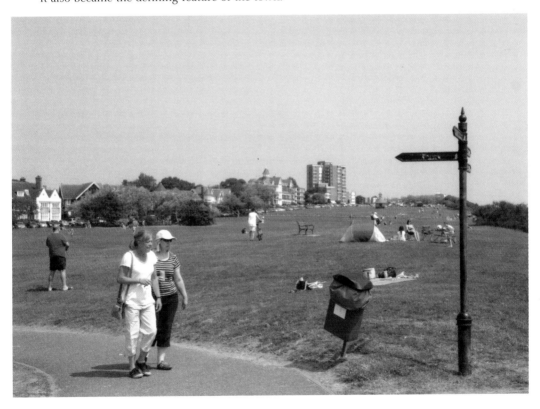

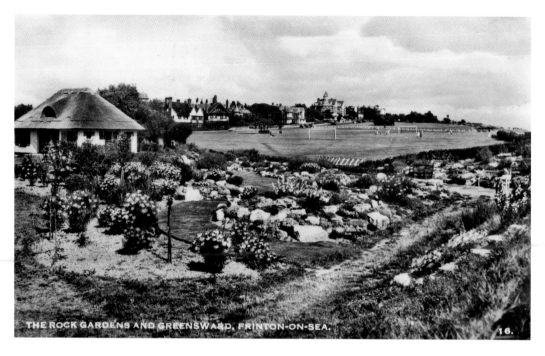

The Rock Gardens and Greensward, Frinton-on-Sea, *c.* 1935
The Rock Gardens were a feature of the seafront where the Greensward gave way to the Golf Links close to the public conveniences. They were removed perhaps around 1960 but today there is a smaller garden at the same point. An interesting feature of the photograph is a football pitch on the Greensward. The old Beach Hotel can just be seen in the distance.

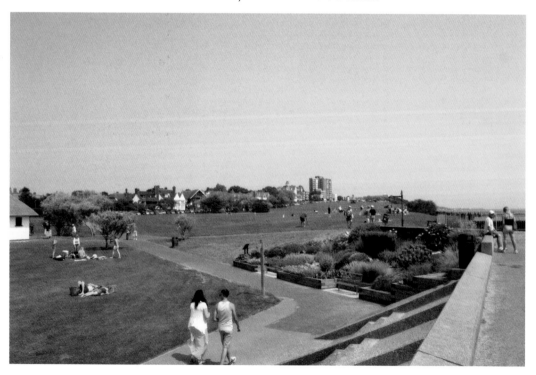

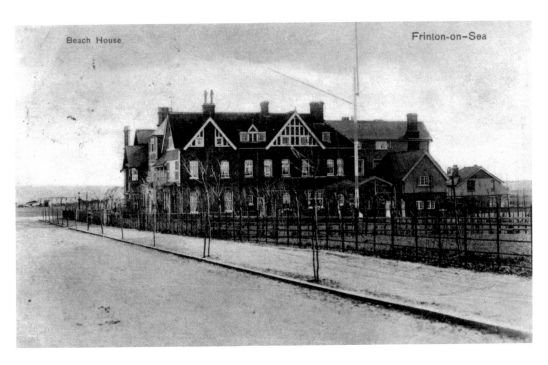

Beach House Frinton-on-Sea

Beach House, Frinton-on-Sea, *c.* 1904
The Beach House or later Beach Hotel was an imposing building at the bottom of Second Avenue. It loomed over the house in the centre. During the Second World War, when it was unoccupied, it received a direct hit from a German bomb on the night of 30 May 1943, destroying it completely.

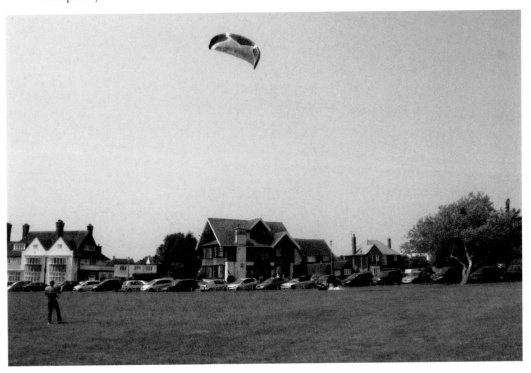

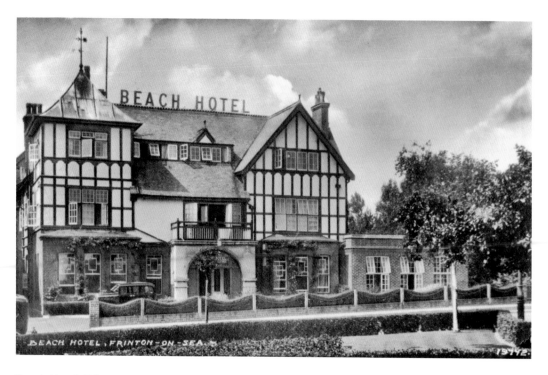

Beach Hotel, Frinton-on-Sea, *c.* 1938
The house that stood on the Esplanade next to the Beach Hotel survived and in 1977 was converted by the Benmore family into The Rock Hotel. Jan Benmore continues to run it today as a traditional family hotel with restaurant. Its brochure now claims that it is Frinton's 'only' hotel, gallantly fighting on while others have been lost or converted into apartments.

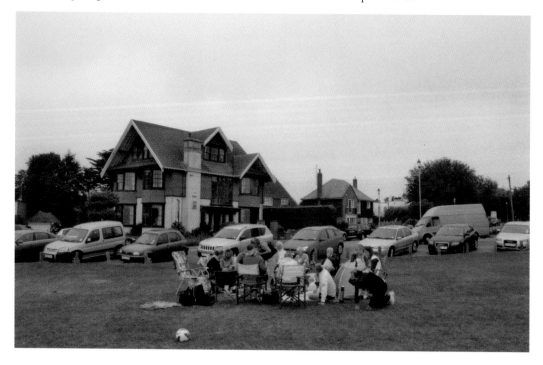

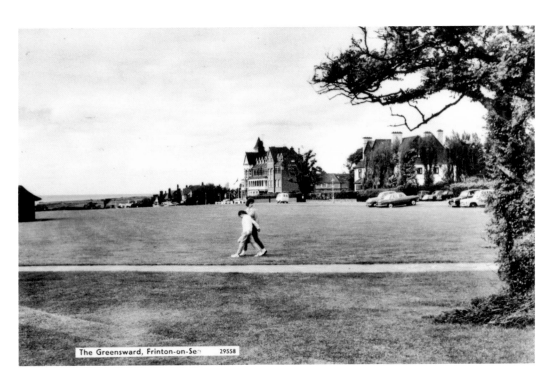

The Greensward, Frinton-on-Sea 29558

The Greensward, Frinton-on-Sea

The Greensward at Frinton is almost as popular as the beach. That is not just when the tide is in, but cars line the edge of the Esplanade and there is picnicking, games and kite flying. I know of nowhere else quite like it. As much as anything it gives Frinton its distinctive character and attraction.

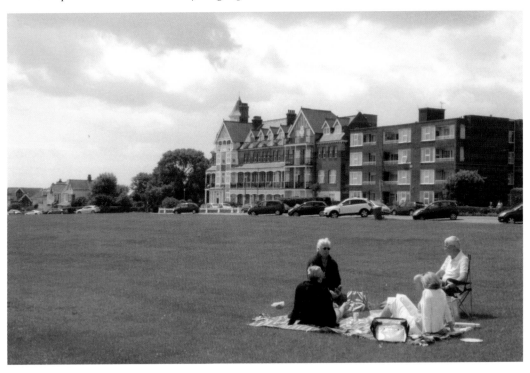

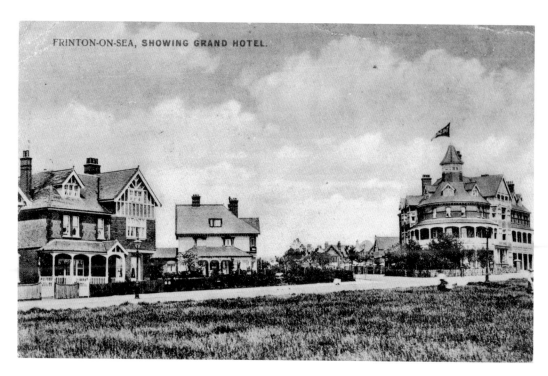

Showing Grand Hotel, Frinton-on-Sea, c. 1904

Early photographs show the Greensward as fairly rough grass. Sheep were grazed on it at this time to keep it short. What a hotel the Grand must have been in its heyday, with its restaurant and ballroom. Some of the finest in the land and probably a few rogues stayed here to be served by the liveried staff.

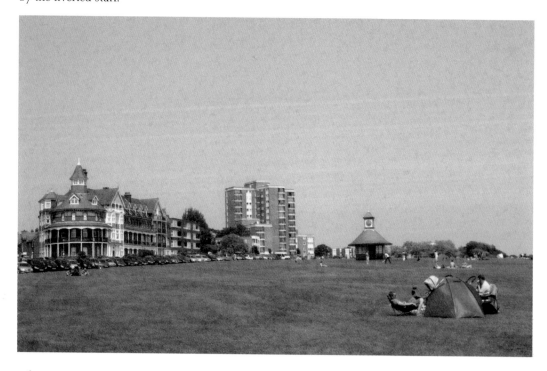

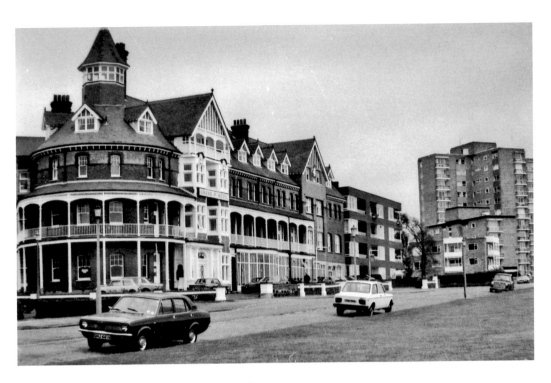

The Grand Hotel, Frinton-on-Sea, *c. 1980*
This was still a hotel when I was there in 1980; the extension was built in 1936. Of course, the massive Frinton Court dominates the photograph. In recent years, the Grand was converted into leasehold apartments, but at least the fine building with its balconies and distinctive turret remains to remind us of the glory days that were.

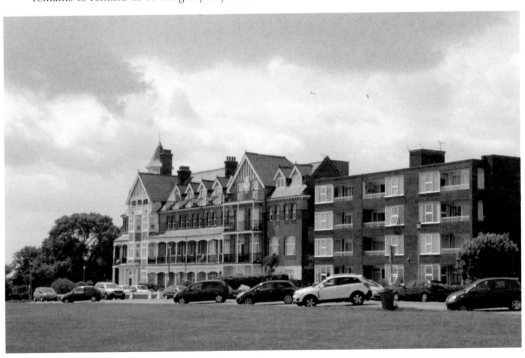

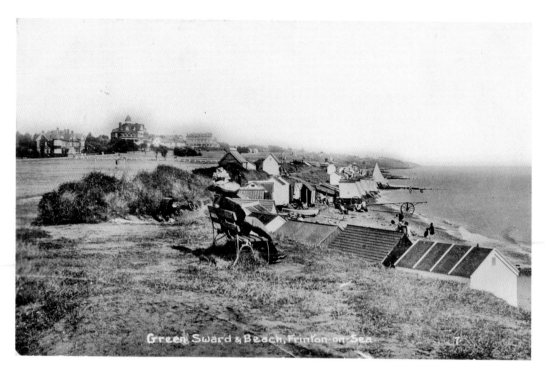

Greensward and Beach, Frinton-on-Sea, *c.* 1912

A wonderful clutter of boats, bathing machines and beach huts. By the time Frinton was developing as a resort the days of people being dipped in the sea for the saltwater cure were over, but mixed bathing was not allowed; neither was undressing on beaches. Bathing machines were used for changing to go for a bathe.

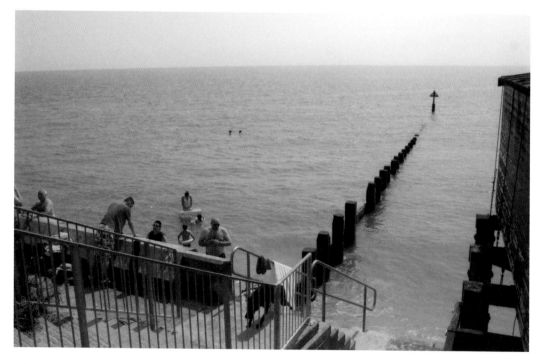

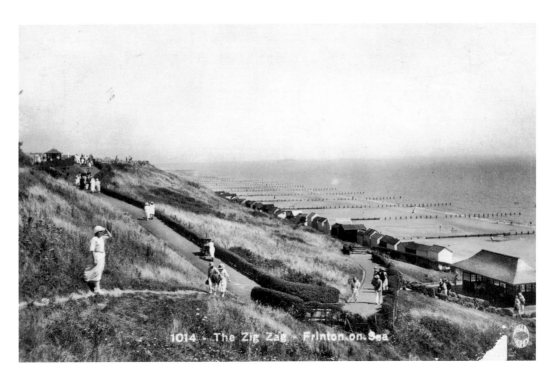

The Zig Zag, Frinton-on-Sea, 1920s

It is not just the fresh sea air and the wonderful views from the Greensward that stir the heart, it is also walking up and down the many sets of steps along the seafront. The classic Zig Zag is opposite Connaught Avenue and is now very much greener and planted than in the early photograph so that it is very difficult to recreate the exact photograph.

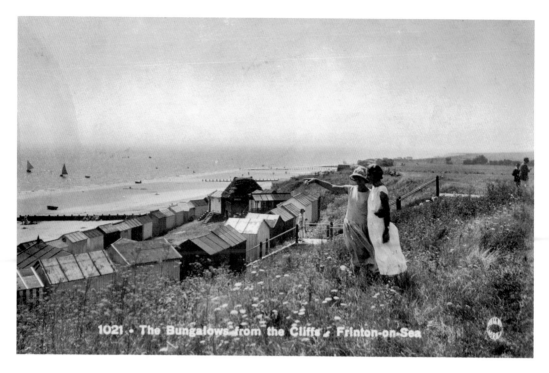

The Bungalows from the Cliffs, Frinton-on-Sea, c. 1933

Sent from Frinton in September 1933 to Tooting with the message, 'This is really a wonderful place but very quiet. Don't work too hard, love...' The beach huts (not bungalows) are now lining the beach and climbing up the cliff. This seems to have been taken near the golf links where there are some wonderful beach huts on stilts served from the promenade and sea wall behind them.

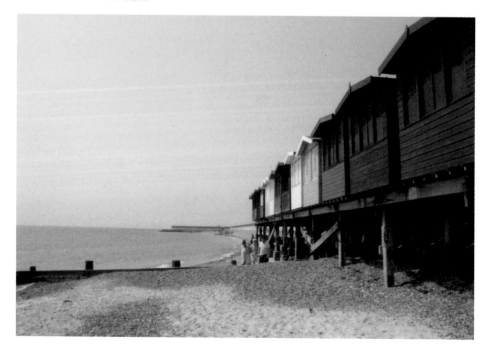

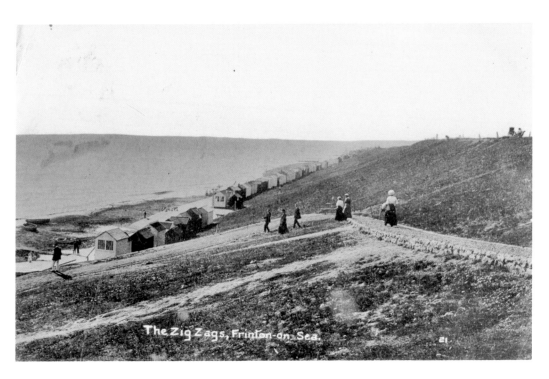

The Zig Zags, Frinton-on-Sea, *c.* 1912
More Zig Zag steps and these look like ones on the east side of Frinton. This is another really good photograph from an anonymous photographer, who did a whole series on Frinton. The message sent to Wisbech in Cambridgeshire is from someone who may well have been convalescing in the resort, as it is dated 12 October 1913: 'Weather much better today. Now going for a walk. Am feeling stronger and hope to be all right by end of week.'

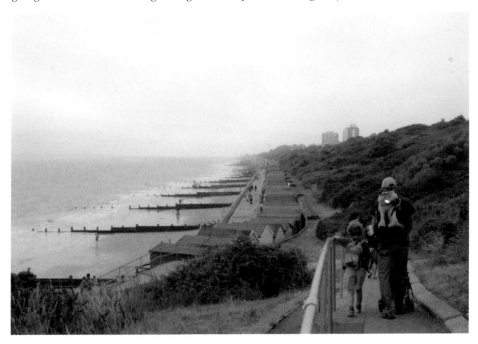

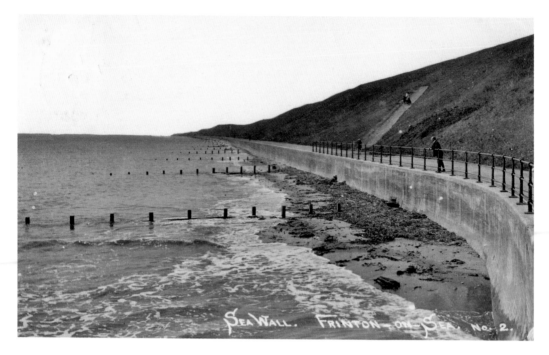

Sea Wall, Frinton-on-Sea, *c.* 1912

My sadly anonymous correspondent to Wisbech writes again on 15 October 2013: 'This seawall is about 1 mile long. Haven't been along it yet. Saw Doctor this morning. He advises me to stay another week so shall probably not go back till the 24th.' The sea walls and defences have provided the ideal platform for the beach huts that are now such a feature of the seafront here.

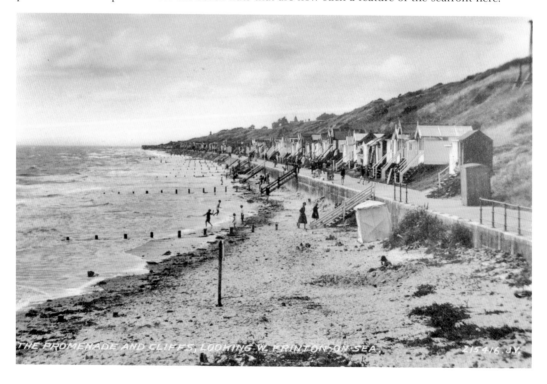

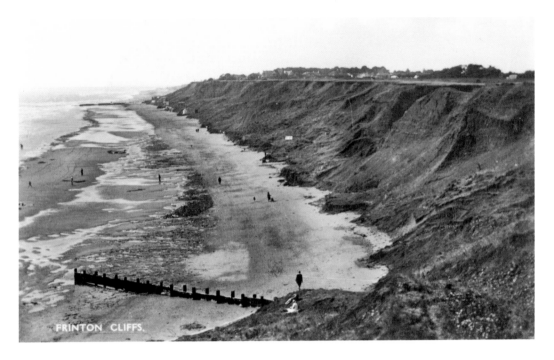

FRINTON CLIFFS.

Frinton Cliffs

Geologists will tell us that both Frinton and Walton sit on a bed of London clay, which is exposed in the cliffs. Without sea defences and protection the cliffs will be eaten away, so this whole stretch is protected by strong sea walls and a promenade. As well as their primary defensive purposes, these structures have opened up a fantastic 7-mile coastal pedestrian and cycle route from Clacton to Walton and a great opportunity for that species of Englishman known as 'Beach Hut Man'.

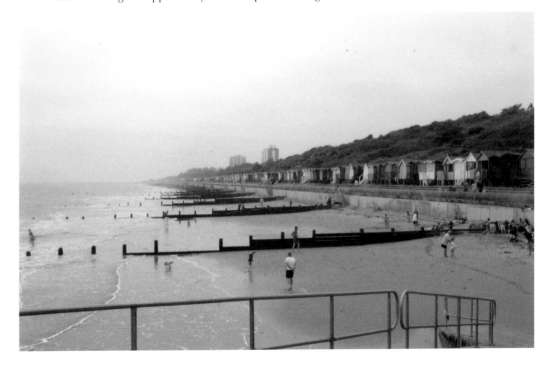

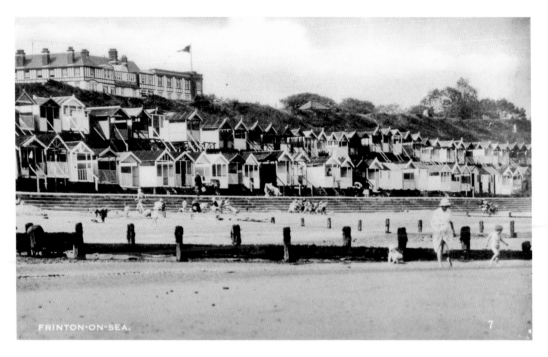

FRINTON-ON-SEA.

The Grand Hotel, Frinton-on-Sea, c. 1946
Wouldn't this be holidaying in style, staying at the Grand and having a beach hut for the length of your stay? The message is back to Bucklebury, near Reading, from Angela: 'We are having a lovely time at the seaside here and I have four bathes a day. We have our hut down on the beach and have our lunch and tea down on the beach, except on Sunday. The weather is quite fine although it is a little windy.' Angela hadn't managed the Grand; she was staying at Mrs Keene's Ashlin, Ashlin Road.

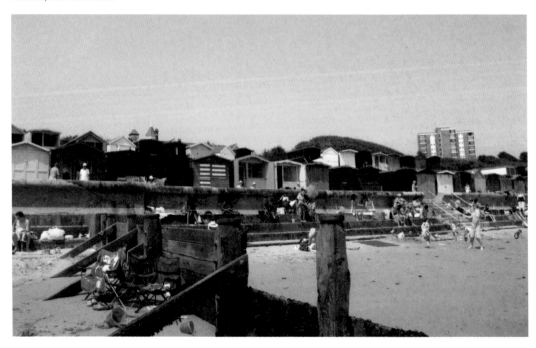

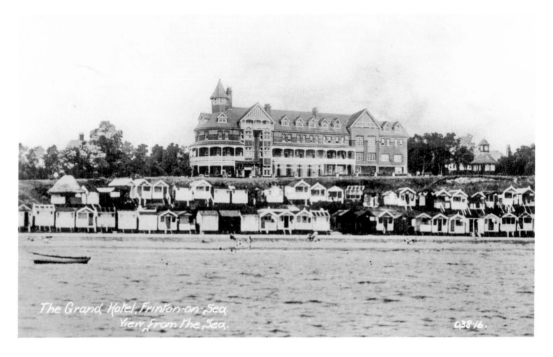

The Grand Hotel, Frinton-on-Sea.
View from the Sea.

038-16.

Frinton-on-Sea, c. 1946

The same idea but a different hotel – this time it is the Esplanade or Hildenborough that crests the Greensward. Stan and Olive weren't doing as well: 'The weather is very disappointing, impossible to sunbathe etc.' It rather looks that sort of day in the photograph and that is why in a few years time the lure of cheap foreign holidays in the sun would change the fortunes of the English seaside.

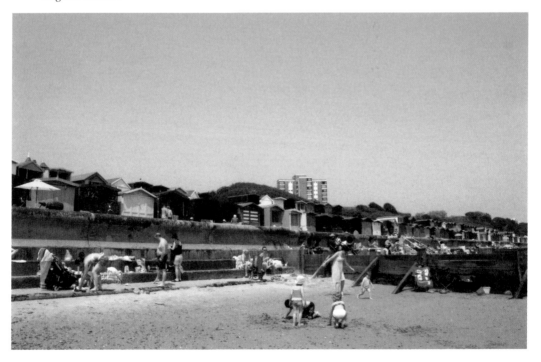

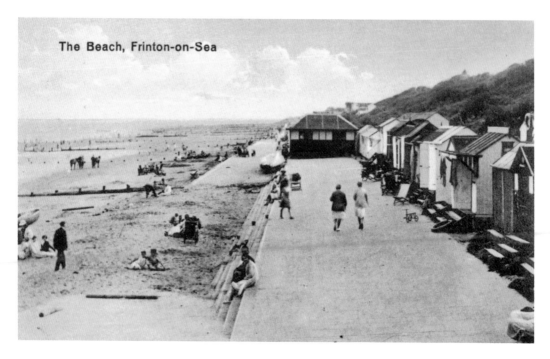

The Beach, Frinton-on-Sea

The Beach, Frinton-on-Sea, c. 1925

The east side of Frinton Beach. In the early 1920s a grand design was proposed at this east end of Frinton to link Frinton and Walton, an idea that Peter Bruff had some forty years before. This was the Frinton Park estate. The railway line was moved further inland in 1930 and the scheme included a luxury hotel as well as a lido, dance hall and café, which was built and can possibly just be seen in the distance.

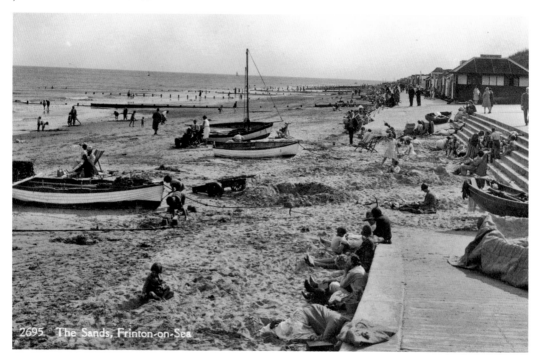

2695 The Sands, Frinton-on-Sea

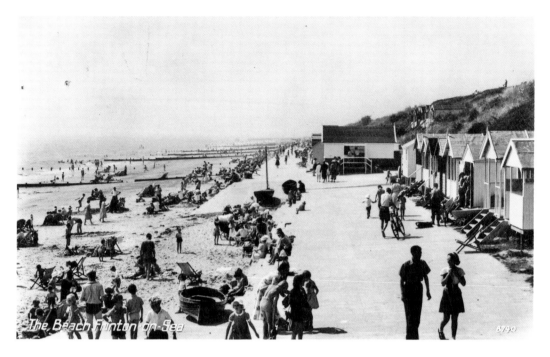

The Beach, Frinton-on-Sea, *c.* 1950

Oliver Hill, the consultant architect for the Frinton Park Estate Ltd, formed in 1934, designed a stunning Art Deco circular estate office, now known as the Round House, but apart from a few buildings the scheme did not take off. In 1936, the company went bankrupt and the lido buildings were demolished because of worries over erosion of the cliffs and then, of course, the Second World War came and Frinton was taken over by the military.

The Cliffs, Frinton-on-Sea, *c.* 1938
The foot of the central Zig Zag below Connaught Avenue and a classic message from Millie and Beryl back to New Barnet in Hertfordshire: 'Still having a good time in Walton on Naze. We went to Frinton yesterday. It's a La de da place. I like Walton best.'

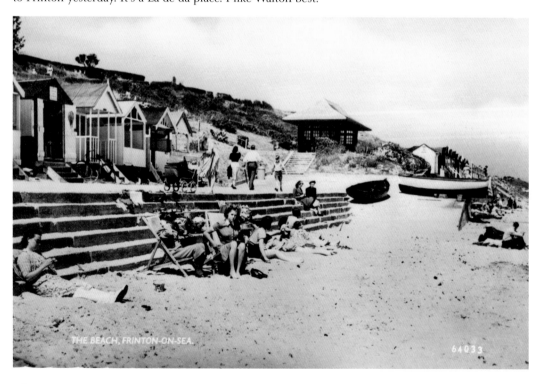

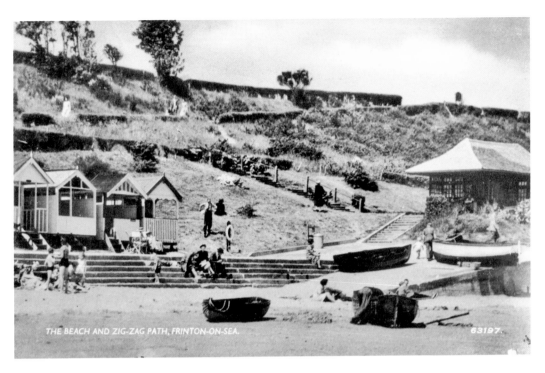

The Beach and Zig Zag Path, Frinton-on-Sea

Still very recognisable today with the same shelter sitting on top of its mound. The bushes and shrubs have grown up more and the beach huts are there. The main difference is the sea wall, which now gives greater protection.

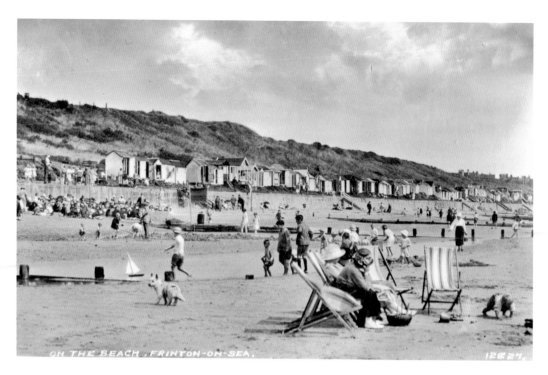

On the Beach, Frinton-on-Sea, *c.* 1937

'La de da' Frinton between the wars was one of the most fashionable seaside towns in the country. Winston Churchill, the actress Gladys Cooper, the swashbuckling film star Douglas Fairbanks and the entertainer Gracie Fields all stayed in Frinton, drawn by the other people of fashion and the golf and tennis, where Wimbledon stars would compete in tournaments.

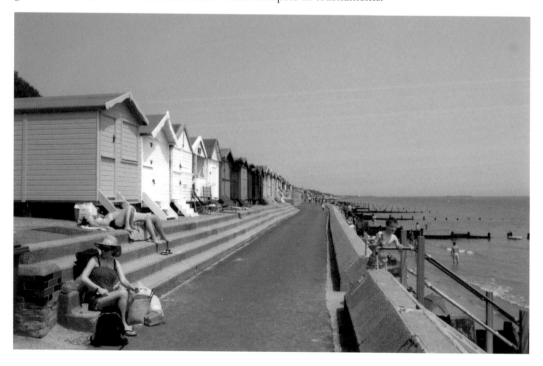

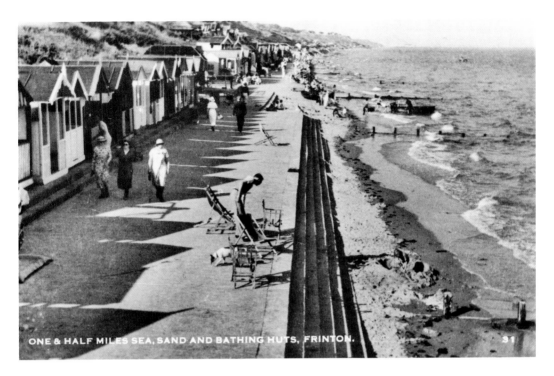

ONE & HALF MILES SEA, SAND AND BATHING HUTS, FRINTON.

One and a Half Miles of Sea, Sand and Bathing Huts, Frinton-on-Sea, *c.* 1936

That was it really for the sun and beach lover. There were no ice cream parlours along the front, no beach shops with Kiss-Me-Quick hats, no amusement arcades with music blaring out and the clatter of coins vanishing noisily into ever-hungry machines. So no children pleading for more money, just a glorious beach that was washed by the sea, leaving beautiful clean sand by the bucketful.

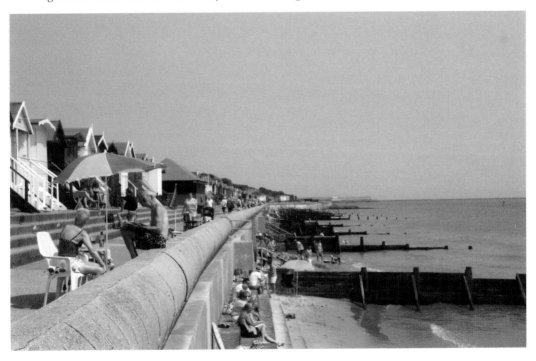

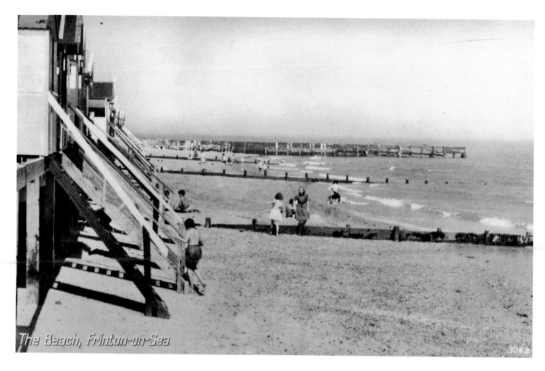

The Beach, Frinton-on-Sea, *c.* 1950

The huts with their steps up to the doors are still along the eastern beach at Frinton, but now they are also up on the promenade, protected by a strong sea wall. The East Coast floods of 1953, when many lives were lost nearby at Jaywick and there was serious flooding at Harwich, led to sea defences being strengthened all along the Essex coast.

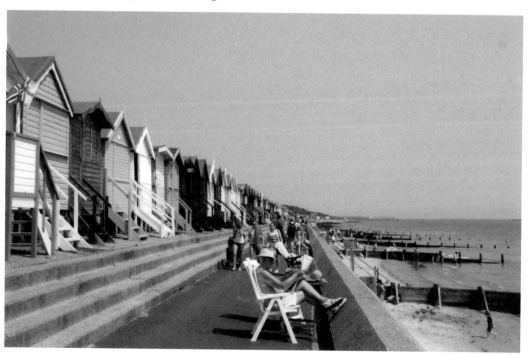

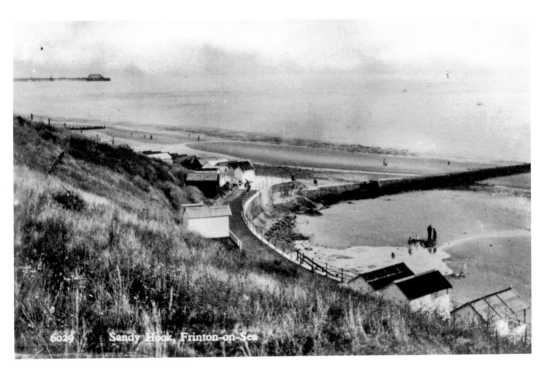

Sandy Hook, Frinton-on-Sea, *c.* 1958

Sent from Pat to Wilmslow, Cheshire, on 25 August 1958: 'I am having a lovely holiday, I shall not be back on Wednesday to come to music.' On 6 July 2013 the glorious hot summer weather has created a scene as crowded as the 1930s.

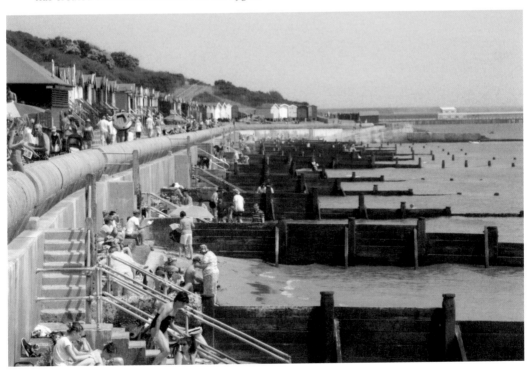

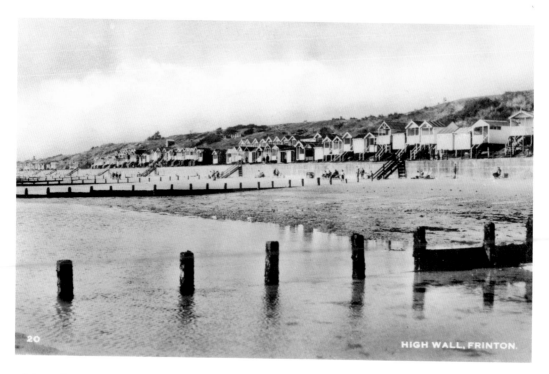

HIGH WALL, FRINTON.

High Wall, Frinton-on-Sea

Despite various plans over the years it is still difficult to get through from Frinton to Walton by car except by going out through the railway gates – sorry barrier now – and along the main road. Walking or cycling is a different matter and the two neighbours are joined along the promenade with the beach huts nearly meeting.

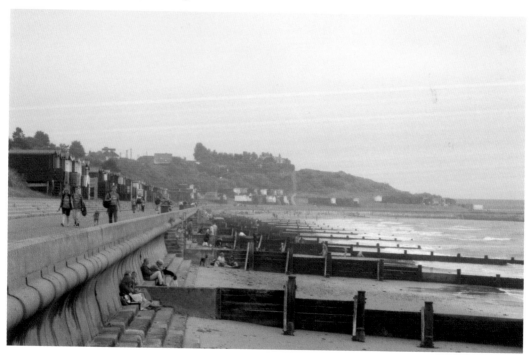

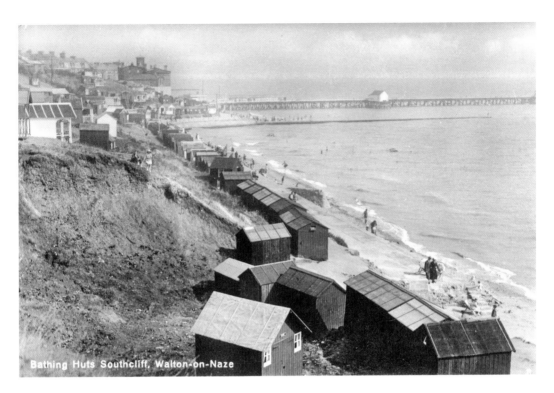

Bathing Huts Southcliff, Walton-on-Naze

Bathing Huts Southcliff, Walton-on-the-Naze, *c.* 1925
Beautiful clean sand and miles of beach huts. The south end of Walton is similar in feel to Frinton. Again the massive sea wall protects the coastline.

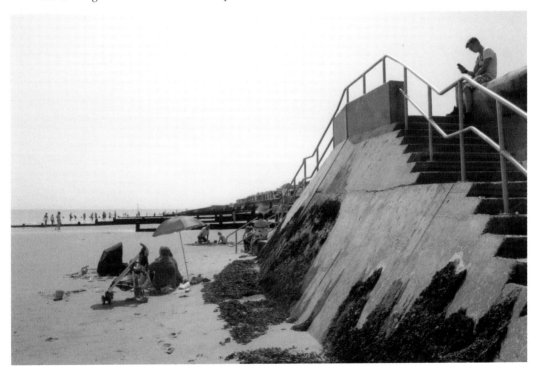

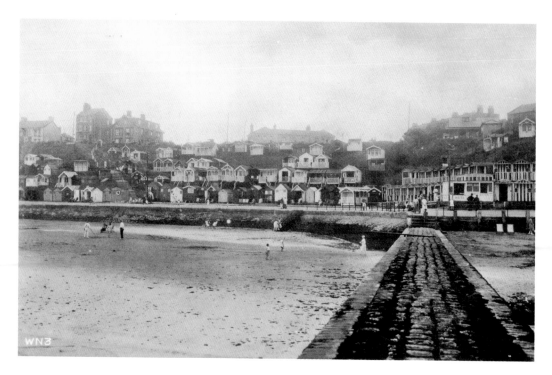

South Beach Bathing Huts, Walton-on-the-Naze, c. 1925
Walton is famous for its beach huts. Here they are overlooked by the white houses on the private Southcliff where the notice proclaims: 'Private Road. No parking. No Turning. Vehicle access residents only', and the track peters out after a short distance.

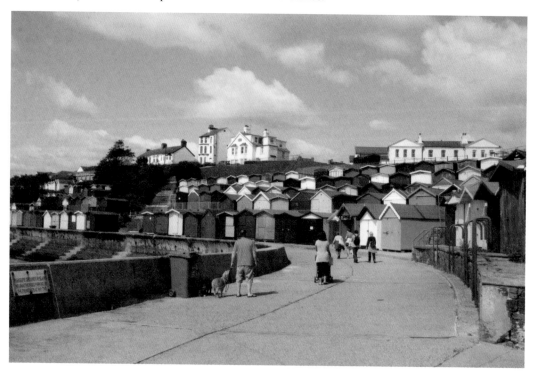

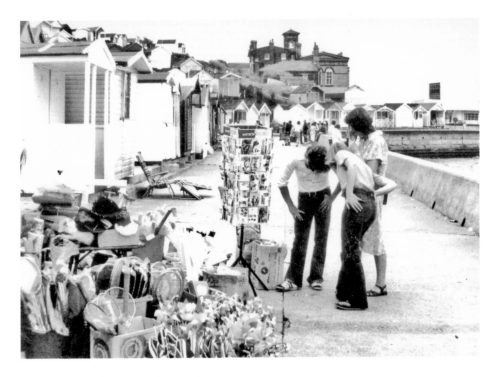

Beach Huts and Promenade, *c.* 1980
Spot the difference between Frinton and Walton now?

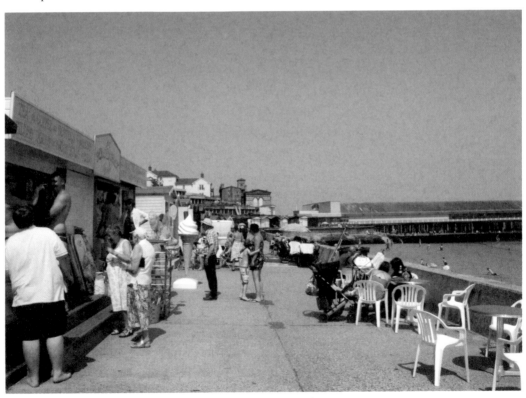

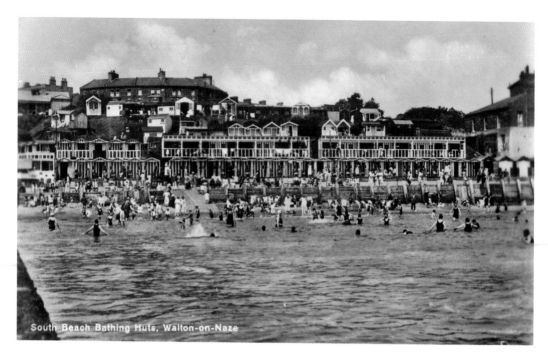

South Beach Bathing Huts, Walton-on-Naze

South Beach Bathing Huts, Walton-on-the-Naze, *c.* 1925
Just when you may think that it is impossible to squeeze in any more, this year new terracing
is being constructed close to the pier and the sign proclaims: 'Walton Beach Huts – Brand new
beach huts available from July.' Since beach huts change hands for considerable sums of money,
here is a new opportunity to claim a little piece of England by the sea.

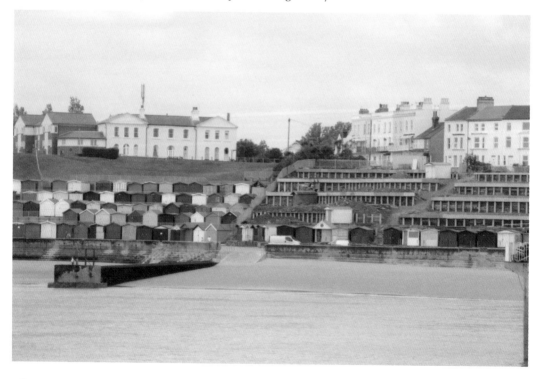

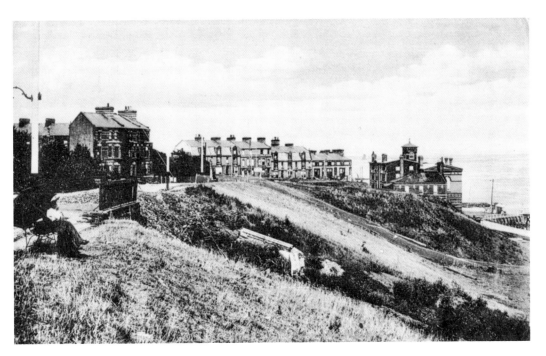

The Cliffs, Walton-on-the-Naze, *c.* 1905

Several entrepreneurs had plans for Walton, one of them being Peter Schuyler Bruff. In 1855 he bought Burnt House Farm on this southern edge of the town and all the land that went with it. Bruff was a man of extraordinary vision and enterprise. His work as the first engineer of the Eastern Union Railway saw him bring the railway from London to Colchester. This photograph shows the heart of Bruff's Walton and South Terrace, which was destroyed by bombing in the Second World War.

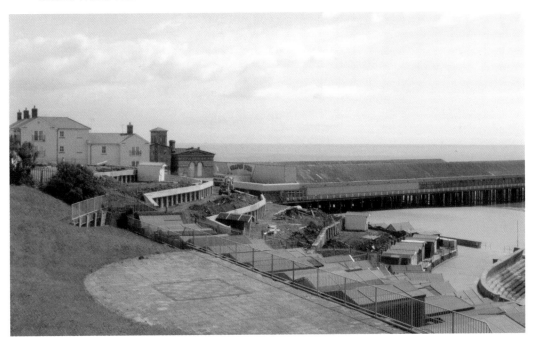

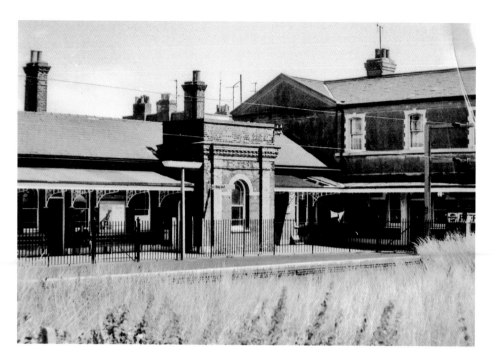

Walton-on-the-Naze Station, *c.* 1980

In 1864, Bruff began extending the railway line from Colchester to the coast through Frinton to Walton. In 1867, the new railway station was opened for Walton, convenient for Bruff's new developments. The old station building is now Great Eastern Court and a simple and more modern structure stands alongside it. Around the new railway station fine villas were built in this elevated position. Bruff built the Marine Terrace and South Terrace, improved the water supply and built a gasworks.

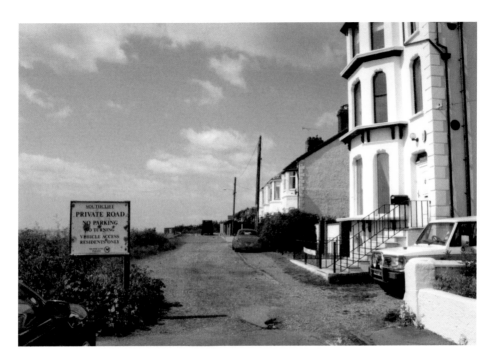

Southcliff and Crescent Road, 2013

With the railway in place and all this new building it might be assumed that Walton was flourishing but C. S. Ward, who visited there in 1882 for his new *Thorough Guide to the Eastern Counties*, wrote: 'Some years ago Walton was a favourite resort, late in the year, with quiet-living folk, who wanted to do nothing, could perfectly succeed. In a measure it is so still, but the place has about it rather the shabbiness than the respectability of age.'

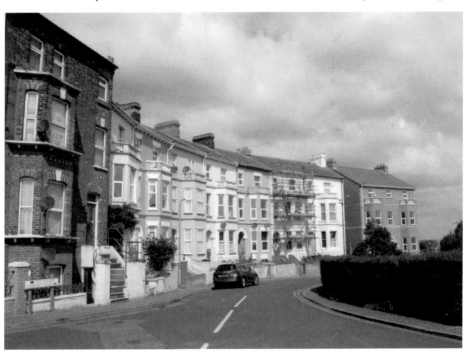

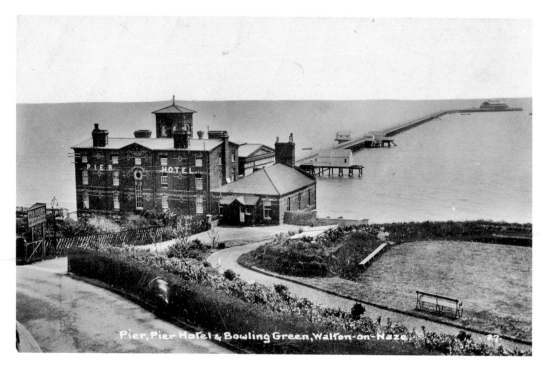

Pier, Pier Hotel and Bowling Green, Walton-on-the-Naze, *c.* 1912

What at first was called the Clifton Baths, which was much more than indoor baths overlooking the sea, but also a Music Hall, a reading room and a billiards room, later became known as the Clifton Hotel. The Clifton name has been brought back in the apartments building more recently built at the rear of the original.

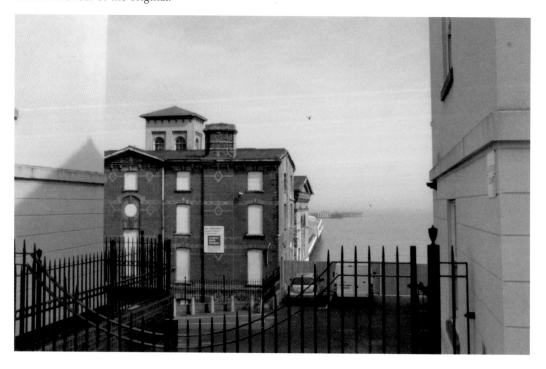

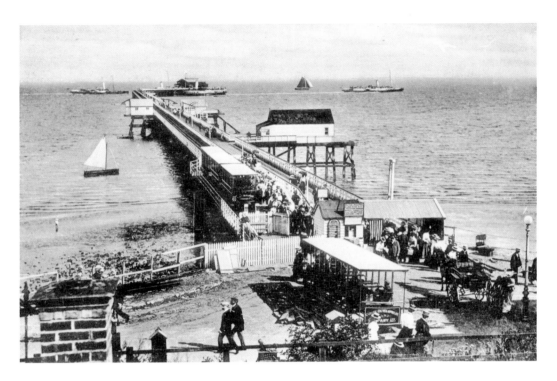

The Pier, Walton-on-the-Naze, *c.* 1900

In 1869 Bruff began constructing a new pier opposite his hotel. His new pier was in competition for the steamer trade with the pier opposite the Marine Hotel. In 1881 he had better fortune with his pier than did the owner of the original structure, which was destroyed in a storm. The Coast Development Company Ltd extended Bruff's pier, opening in August 1898. This incredible photograph shows four Belle steamers visiting or leaving Walton.

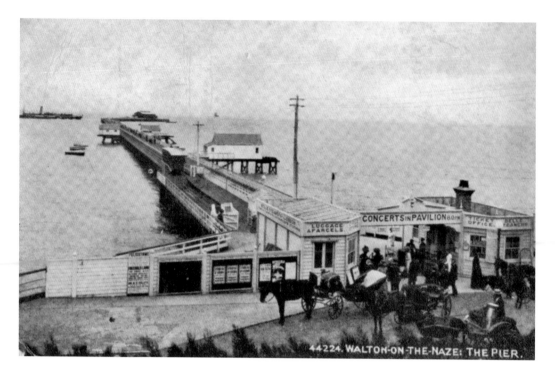

Walton-on-the-Naze, the Pier, *c.* 1910

Despite the railway, this was the golden age of the coastal steamers, and from Walton it was possible to visit Clacton, Felixstowe, Harwich, Ipswich, Felixstowe, Lowestoft and Yarmouth. There was also a concert hall at the pier head. Walton's pier was at this time the second longest in the country after Southend's. Below, in a photograph from around 1930, the Sea Spray Café also offers dancing every evening.

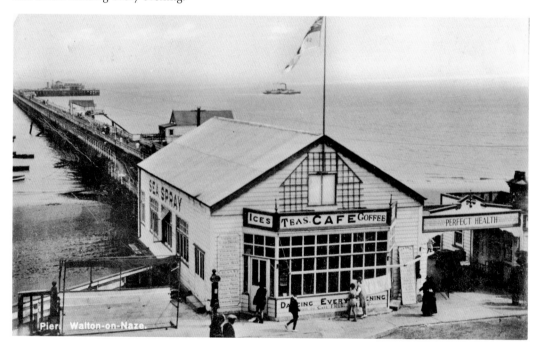

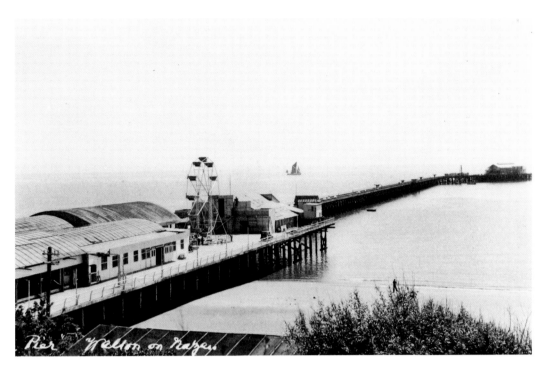

The Pier, Walton-on-the-Naze, *c.* 1938
Like Southend, a feature of Walton's pier was the electric railway along its length of 2,610 feet to the three berthing arms. The original rolling stock consisted of a motor car and two trailers coupled together as one unit. This tramway closed in 1935. In 1936 a new, guided tramway opened for a battery-powered carriage with pneumatic tyres and toast rack seating for twenty, which could be driven from either end.

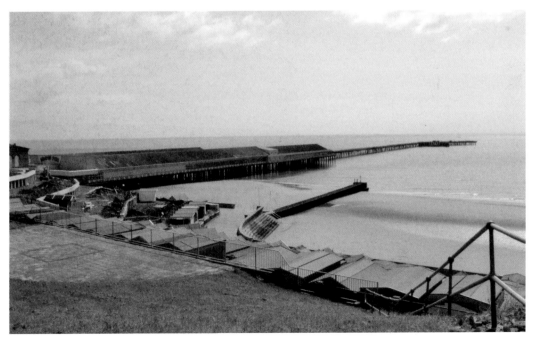

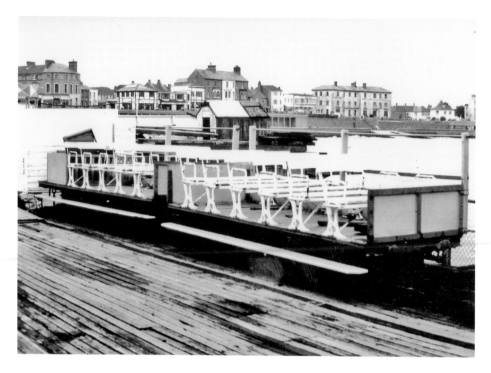

Pier Railway, c. 1980

On 30 May 1942, during the Second World War, the pier and track were destroyed by fire. The pier reopened in 1948 with a new single track and turntable for a new diesel engine, the *Dreadnought*, to pull three toast rack open coaches seating eighteen each. The line ceased operating in the 1970s before I took this photograph but the toast rack coaches were still there.

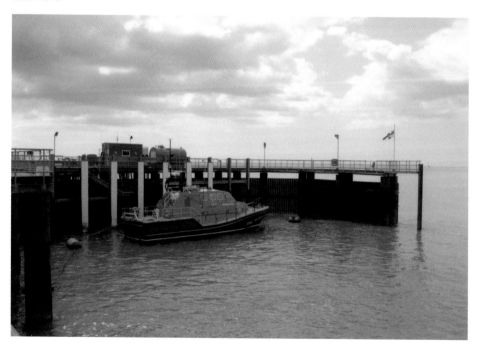

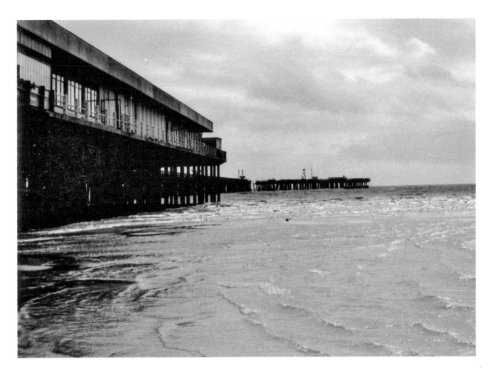

Pier, *c.* 1980

The pier has been owned by the New Walton Pier Company since 1937. Piers are notoriously accident prone. As well as the wartime damage, serious storms in 1978 ripped a 33-metre gap towards the seaward end, cutting off the lifeboat station. The railway line has now gone and the pier provides a popular boardwalk, a place for sea fishermen and access to the lifeboat station.

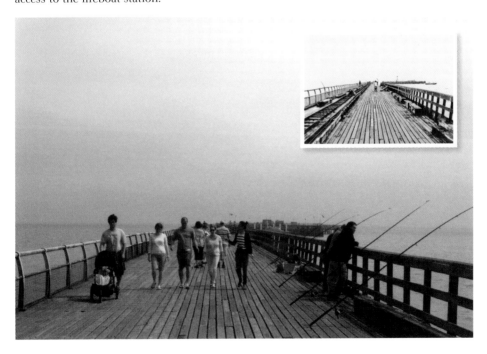

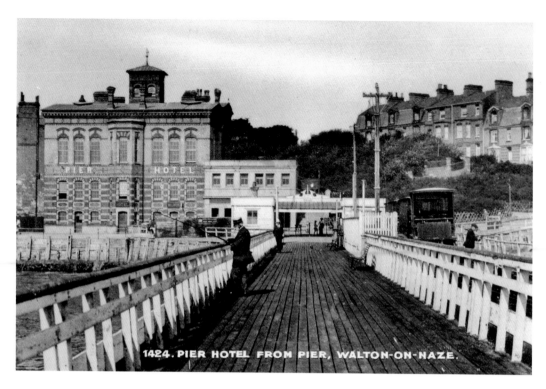

1424. PIER HOTEL FROM PIER, WALTON-ON-NAZE.

Pier Hotel from the Pier, Walton-on-the-Naze, *c.* 1910
What an impressive entrance to Walton for the thousands of visitors who arrived on the Belle steamers. The Clifton was renamed the Pier Hotel in 1896 when it was bought by the Walton Pier & Hotel Company.

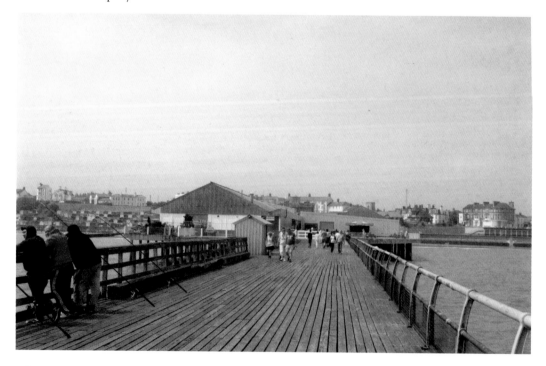

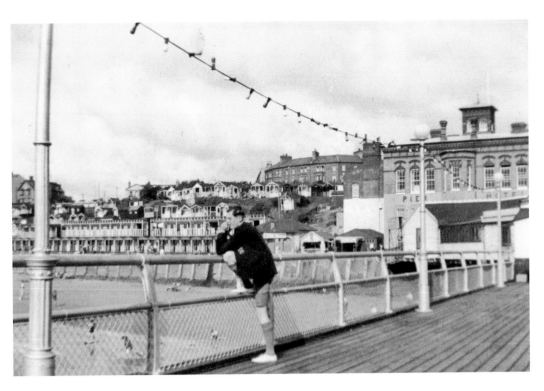

The Pier, *c.* 1925
A nicely staged photograph, but both this and the previous photograph are impossible to recreate today because of the growth of the amusements, which are all under cover.

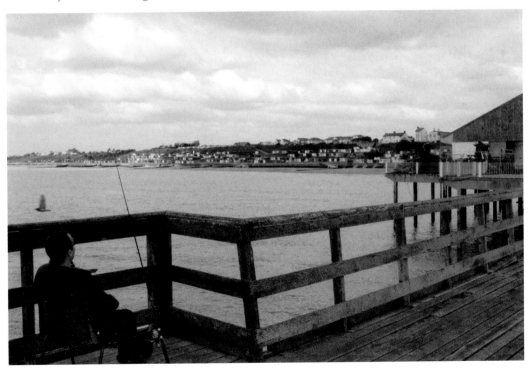

Seaside Entertainers, *c.* 1911

This group is probably Will C. Pepper's White Coons, notable for the young man standing back right, Stanley Holloway, who would later become a huge variety, radio and film star, eventually finding cinematic immortality as Dolittle in *My Fair Lady*. He was one of many entertainers who began their careers entertaining in concert parties. Today, the old concert hall has long gone and the pier's main attractions are all the various rides.

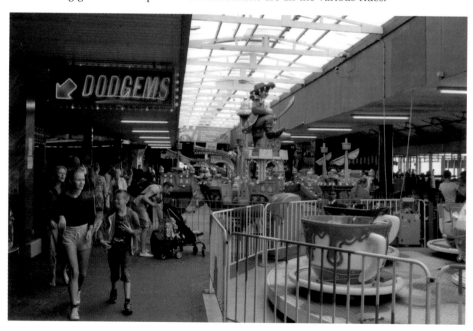

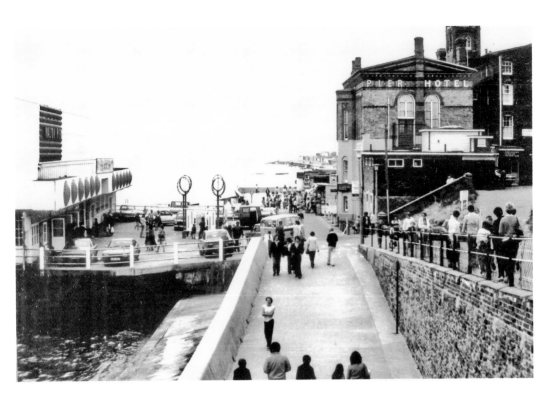

Pier and Hotel, *c.* 1980

The pier façade has developed and a magnificent new toilet block has been built in 2005 on the right, but the poor Pier Hotel looks even worse and it's up for sale in the hope of redevelopment. To the rear of it the Clifton apartments have already been built.

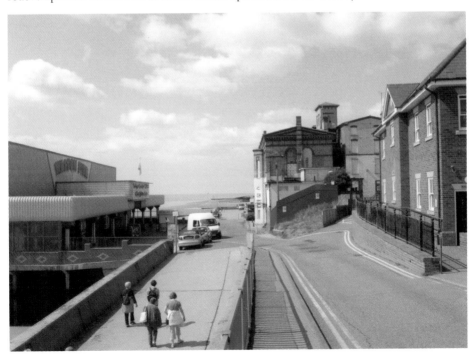

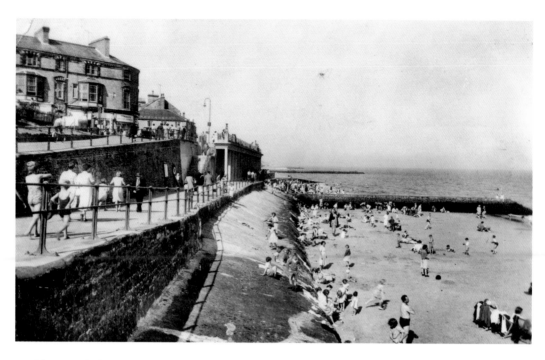

Looking North from the Pier, Walton-on-the-Naze, *c.* 1958
'Enjoying a quiet week, weather quite good, bags of sleep...' Marine Terrace, built by Peter Bruff, can be seen top left. It has now been renamed Bruff Terrace.

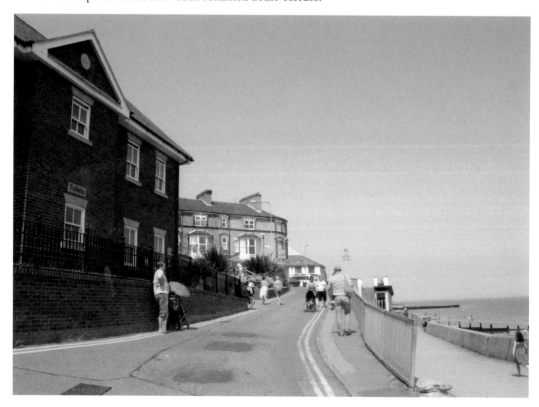

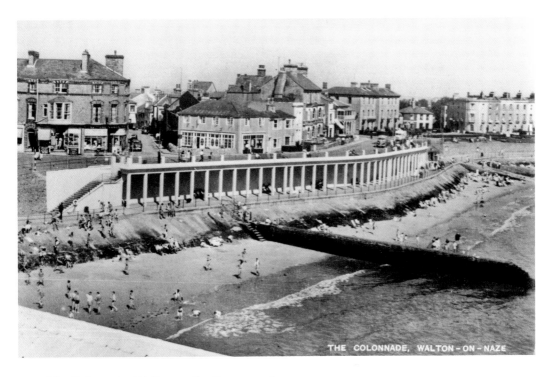

The Colonnade, Walton-on-the-Naze, *c.* 1960

The Colonnade is a striking feature of the lower promenade, but in truth it is rather sad today and seems little used. A new sea wall has been built all along this frontage since this photograph was taken.

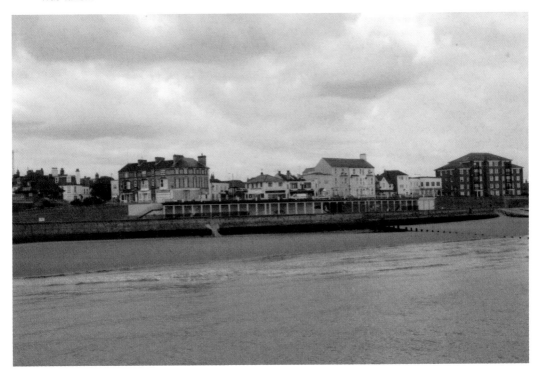

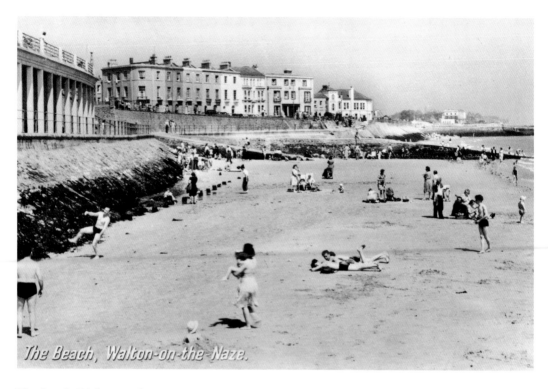

The Beach, Walton-on-the-Naze, *c.* 1950

'Just a line to let you know we are all alright. We are spending August at Walton-on-the-Naze and the weather is really grand.' This is a beautiful clean piece of sand; a glorious spot in the sun.

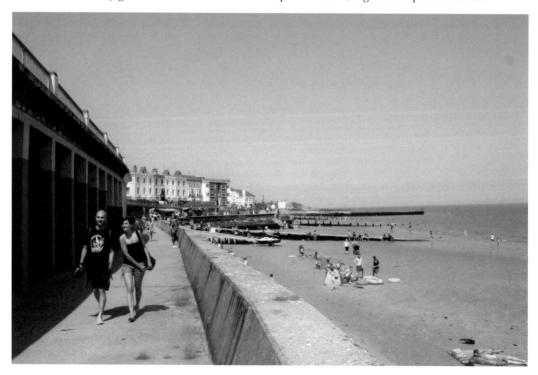

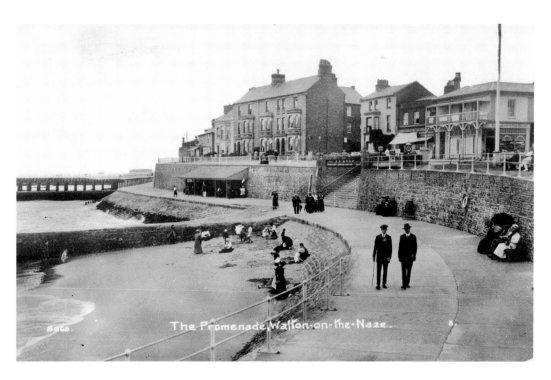

The Promenade, Walton-on-the-Naze, *c.* 1912

This is the same photographer, I'm sure, who took some of those fantastic photographs of Frinton just before the First World War. This time he captures the promenade before the Colonnade was built. Above the promenade on the right is The London Budget Tea Rooms and Restaurant next to Brooke Bazaar.

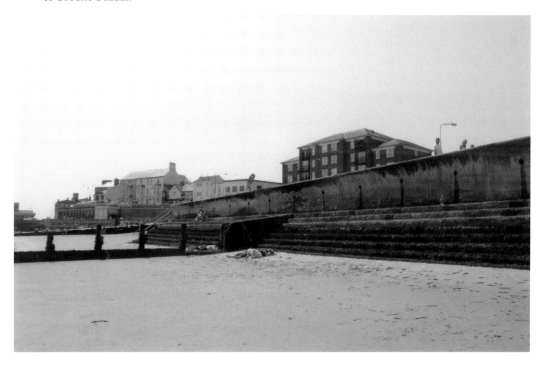

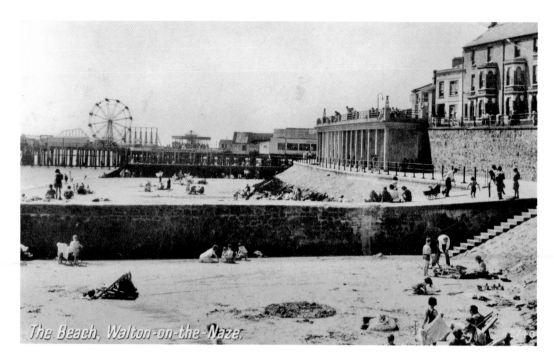

The Beach, Walton-on-the-Naze, *c.* 1951

The open-air amusements can be seen on the deck of the pier with the big wheel and the carousel. Written to someone else on holiday in Bournemouth: 'Hope you are having a nice time as we are still. This morning has been really lovely. We have been playing ball in Naze Park and got too hot. Sunday evening we went to the Roaring Donkey and had a drink and then walked to Holland Beach...'

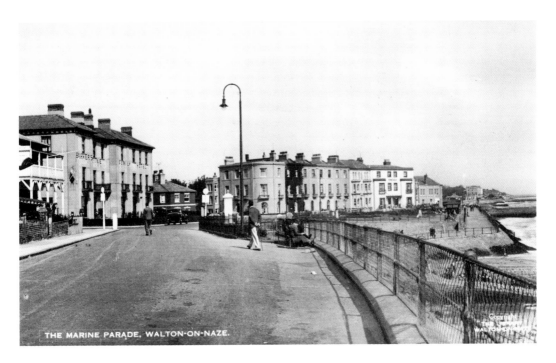

THE MARINE PARADE, WALTON-ON-NAZE.

The Marine Parade, Walton-on-the-Naze, *c.* 1935
'We are A1 and thoroughly enjoying ourselves. Frinton is awfully nice. Have enjoyed a walk to Walton and back to Frinton by bus. We have paddled, the sands are lovely...' Barkers Marine Family Hotel is prominent on the left. This was Walton's first grand hotel and dominated this section of the seafront for over 150 years until demolished in recent years.

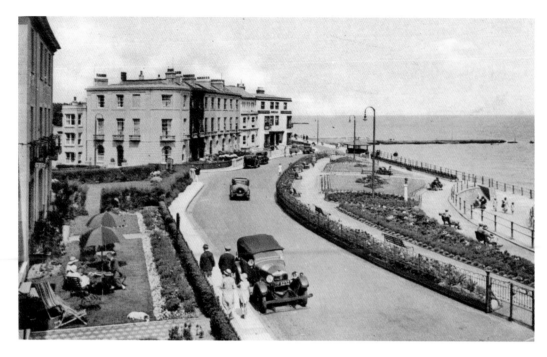

Marine Parade, Walton-on-the-Naze, *c.* 1945

Sent to London in June 1945 when the Second World War was coming to an end and some of the seaside towns that had been restricted were open for business again: 'Greetings from Walton and just to say we are having a nice holiday and good weather.' The beginning of Walton as a seaside resort could be attributed to the building of the Marine Hotel by John Penrice of Colchester in 1829. This hotel was variously known over the years by the names of its owners – Dorling, Kent and Barker.

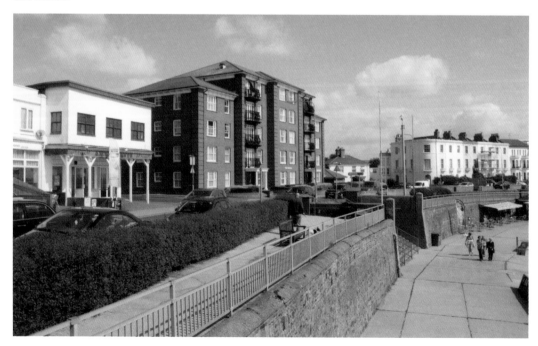

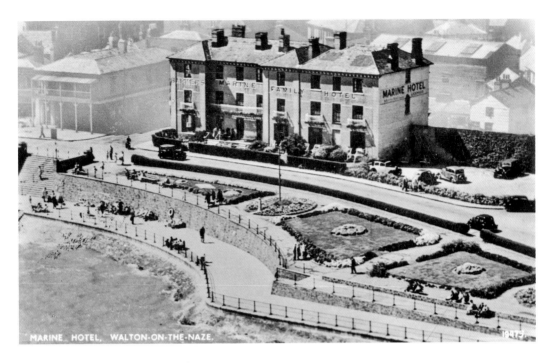

Marine Hotel, Walton-on-the-Naze, *c.* 1935

In 1830, John Penrice built a jetty some 150 feet long in front of the Marine Hotel, making it one of the country's earliest piers. It was lengthened in 1848 to 330 feet. Its purpose was to make a landing stage for the coastal steamers from Ipswich and London, but it could not operate at low tide. The pier was lost in a storm in 1881. The new apartments have been given the name of one of the previous owners of the hotel – Dorlings.

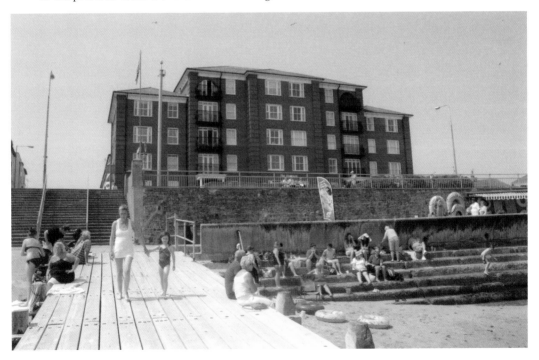

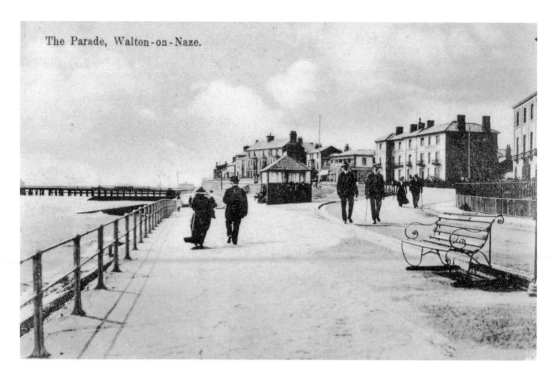

The Parade, Walton-on-Naze.

The Parade, Walton-on-the-Naze, *c.* 1913
Not exactly the noisy, busy resort of today yet, more a place for quiet strolls along the promenade and taking the sea air. Below, from the 1920s, the Marine Gardens, which were laid out after Walton's first pier was built, look very well maintained and the whole scene is still very genteel.

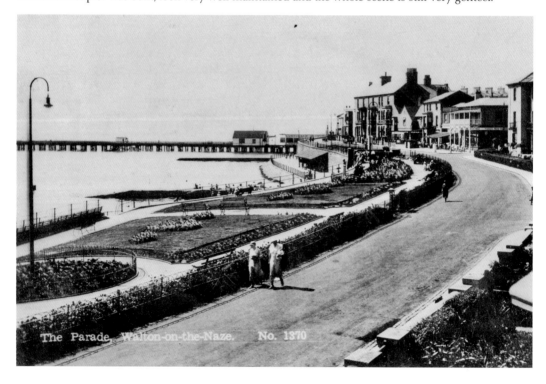

The Parade, Walton-on-the-Naze. No. 1370

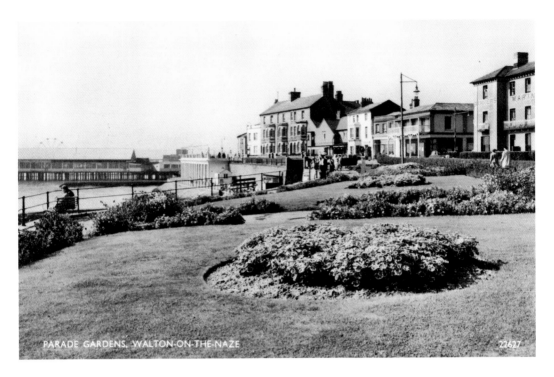

Parade Gardens, Walton-on-the-Naze, *c.* 1960
'Today we had a trip here (from Clacton). It is a nice little place. We had a shower this afternoon, but it was while we were at tea.' However trite the message, the postcard was still to be sent back home to friends and neighbours while on holiday and it would get there before you returned.

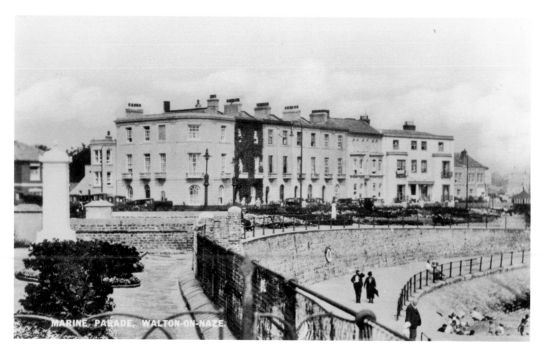

Marine Parade, Walton-on-the-Naze, *c.* 1950
A fine parade of buildings that is still instantly recognisable. The long terrace was designed by
John Penrice and dates from the 1830s.

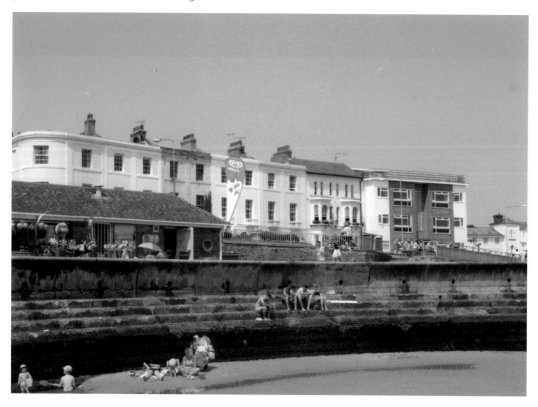

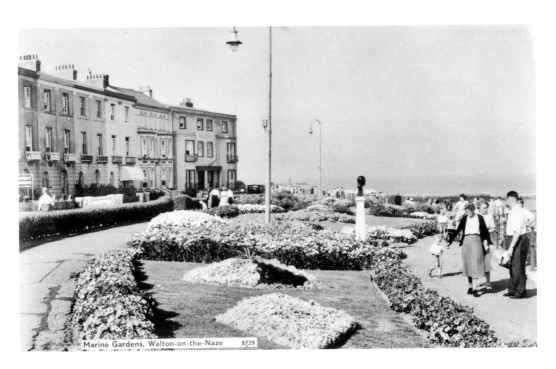

Marine Gardens, Walton-on-the-Naze, *c. 1962*

The bust on a plinth that can be seen in the Marine Gardens is in honour of Pte Herbert Columbine VC (1893–1918). Pte Columbine stayed at his machine-gun holding back the Germans, sent his two colleagues to safety and continued firing until killed by a bomb. Although he was a Londoner his family frequently visited Walton and presented his medal to the town. The memorial is now in the churchyard, but there is hope of raising a statue to him.

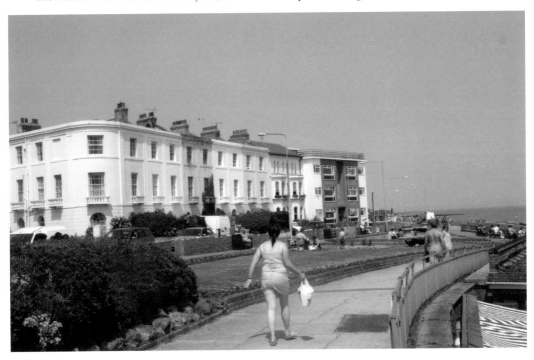

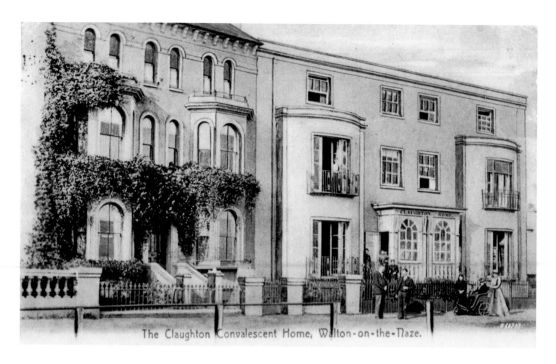

The Claughton Convalescent Home, Walton-on-the-Naze.

The Claughton Convalescent Home, Walton-on-the-Naze, *c.* 1908

Expensive modern reports extol the health benefits of fresh air, open space and a view, as if it is something new. A hundred years ago and more, recovering patients were sent from hospital to homes like the Claughton, which was one such supported by voluntary contributions. The Claughton became the Ranelagh before being replaced by the modern Ranelagh apartments, which for a change is quite a well-judged building in such a position.

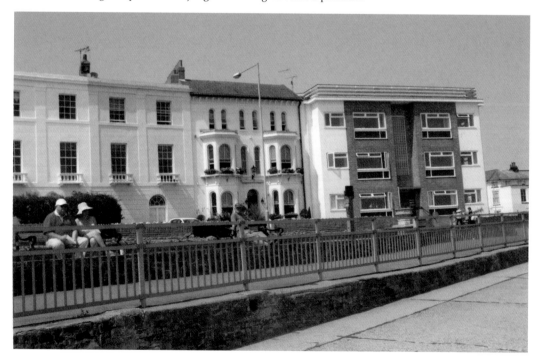

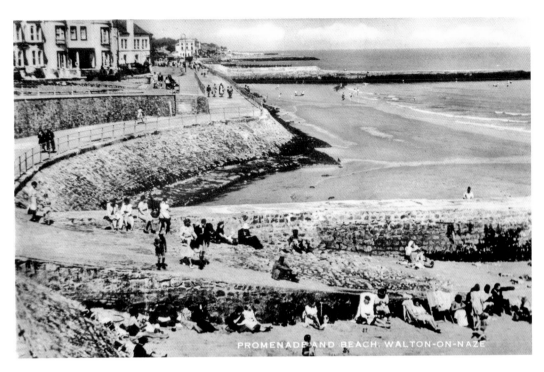

Promenade and Beach, Walton-on-the-Naze, *c.* 1950

Some of the main features of the Walton seafront are the huge stone groynes or breakwaters. They are all of similar design and dating from Victorian times. This one, however, opposite the Marine Gardens, is now a wooden jetty with the small café and shop nearby on the lower promenade.

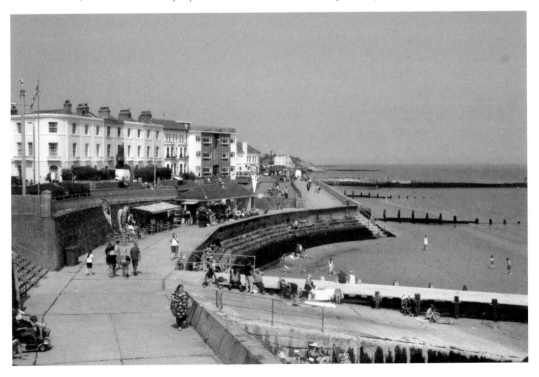

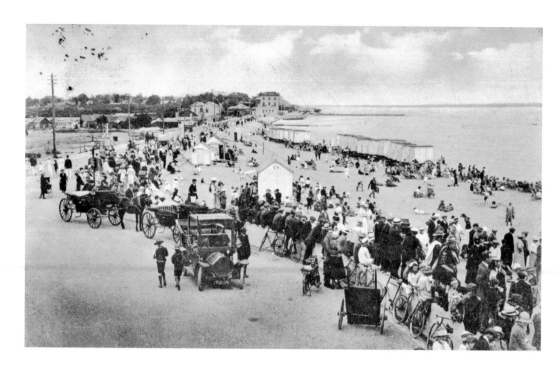

The Beach and Shore Road, *c.* 1910
The Bates family operated the bathing machines along this stretch of Albion Beach. The photograph has both horse-drawn carriages and an early horseless carriage in the foreground. Bands played on the beach and, as ordinary tides did not cover all the sands, this was where a concert party stage stood, just out of the photograph on the right, which may well account for the large crowd gathered watching. The original Bath House can just be seen.

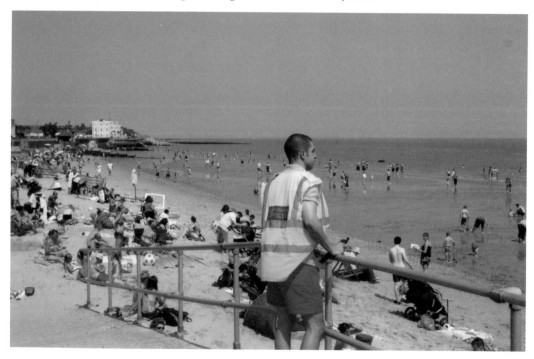

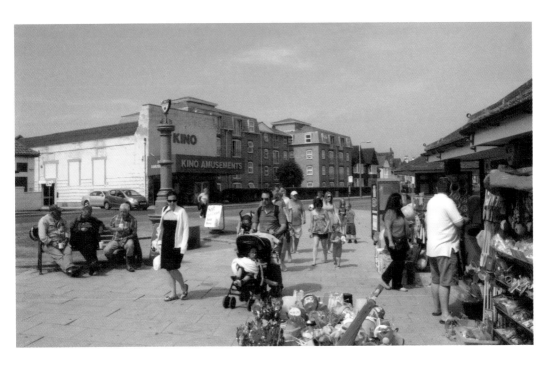

Prince's Esplanade, 2013

Shore Road became Prince's Esplanade after being officially opened by the Duke of Kent in 1930. The Kino Cinema opened in 1916 and after closing became a café. It is now an amusement arcade. Below, the Bathhouse Hotel was built in the early part of the nineteenth century and survived until the present hotel was built in the 1930s. There was live music coming from a small stage when I was there and people were sitting on the sea wall listening. Bring back the concert parties I say!

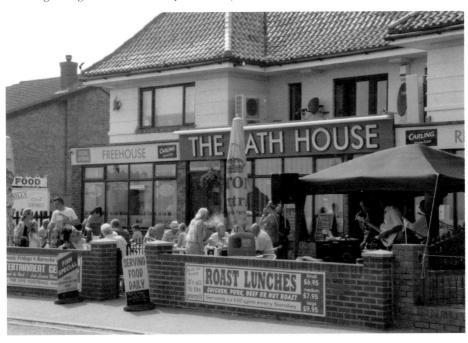

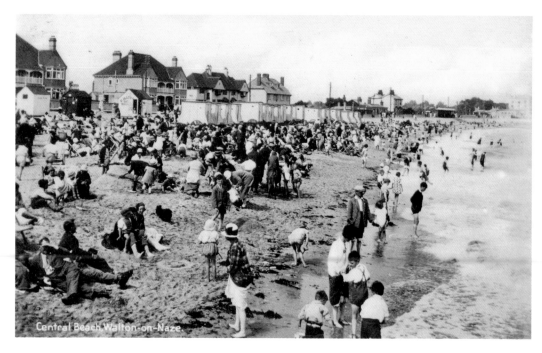

Central Beach, Walton-on-the-Naze, *c.* 1925

Bates' bathing machines line the seafront, providing changing rooms for the crowded beach. The old Bath House can be seen beyond them on the Shore Road. Like most English seaside resorts, the years between the two wars saw their best and busiest summer seasons and Walton was doing well for a smaller resort.

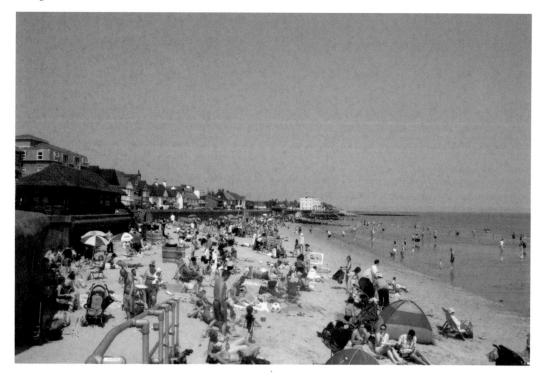

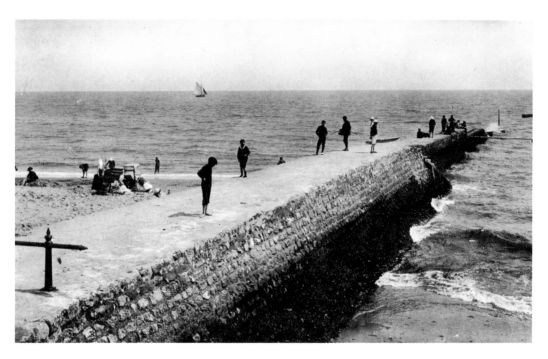

The Groyne, Walton-on-the-Naze, *c.* 1912

If I am right this is the groyne at Albion Beach, named after the nearby Albion Hotel and public house. They stop the sand being dragged along the beach, provide shelter and prove irresistible for people to clamber on, despite warnings.

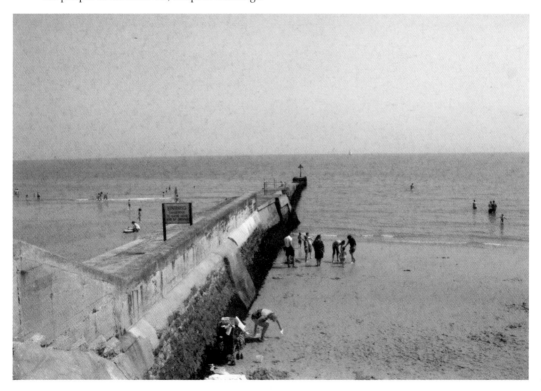

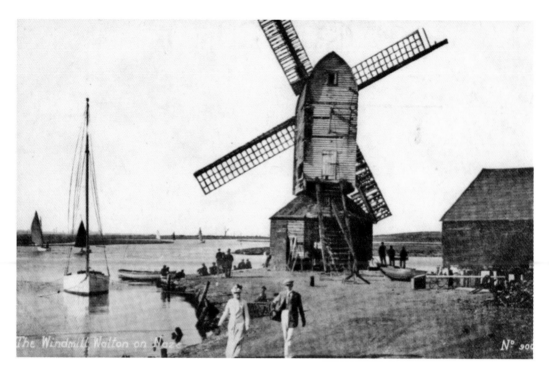

The Windmill, Walton-on-the-Naze, *c.* **1920**
Behind Walton and approached from Mill Lane there were once two ancient mills. From 1832 John Archer owned them both. The windmill was a post mill grinding corn. After some inactive years it was demolished in 1921 and the Yacht Club building now occupies the site. The Town Hard Association, founded in 1963, manages the moorings for local boat owners.

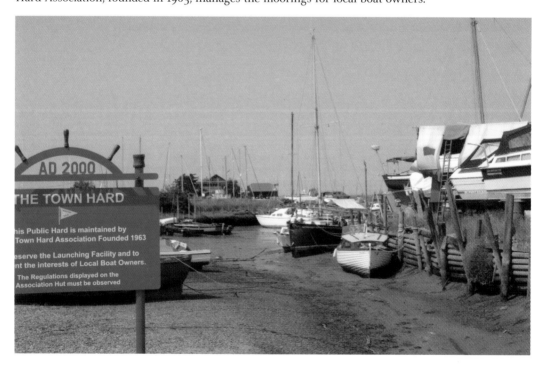

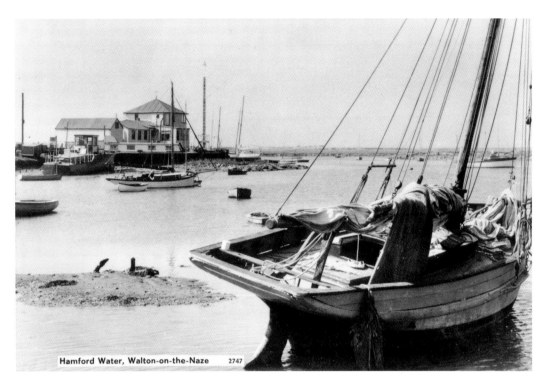

Hamford Water, Walton-on-the-Naze 2747

Hamford Water, Walton-on-the Naze, *c.* 1964
The Walton Channel takes boats from the marina out into the North Sea. Once it would have been used for trade but now it is mainly leisure craft.

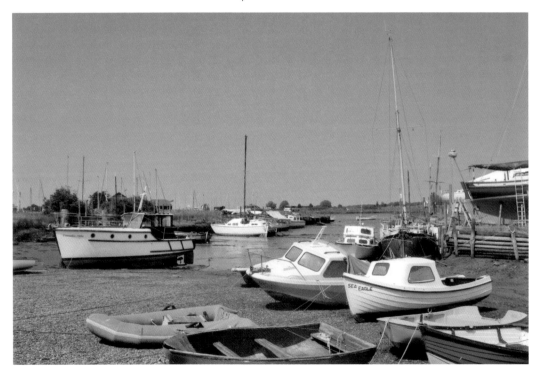

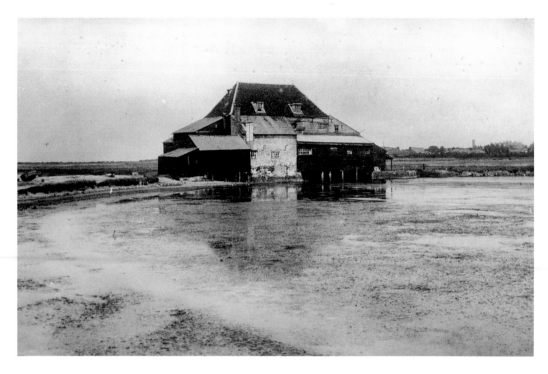

Old Tidal Mill, Walton-on-the-Naze, *c.* 1908

The Tidal Mill was also a corn-grinding mill. It stood on the Mill Pond, known locally as the Mere. A sluice let through water from the Walton Channel to drive the mill. Corn was ground and grain and flour were shipped to the North of England while coal was brought back. In 1921, the watermill was taken down and the Mill Pond became a very popular boating lake, seen below in around 1960.

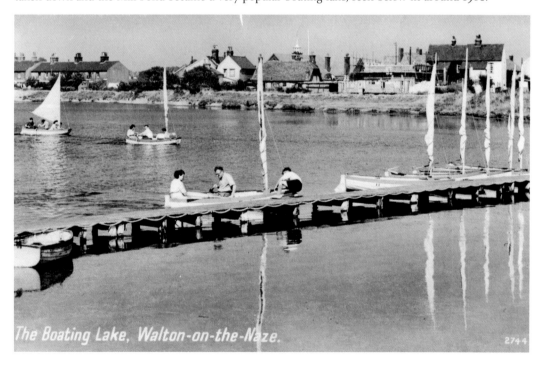

The Boating Lake, Walton-on-the-Naze.

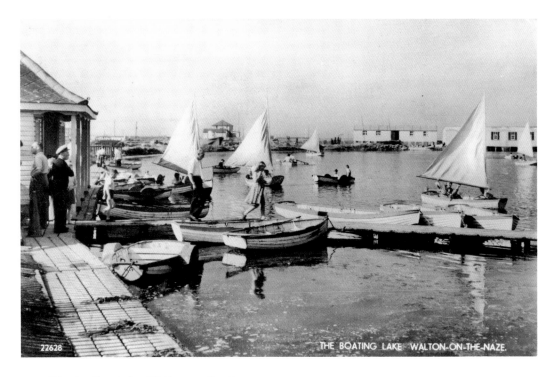

The Boating Lake, Walton-on-the-Naze, *c.* 1970

What a glorious site in its heyday! The boating lake closed in 1976 and since then there have been many proposals for the site. After the original owner died in 2004, the new owners, the Titchmarsh family, came forward with ambitious proposals for a supermarket, housing and a marina in 2011, which provoked strong local opposition. The future remains uncertain.

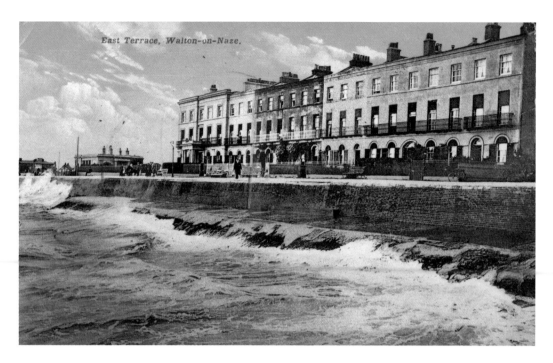

East Terrace, Walton-on-Naze.

East Terrace, Walton-on-the-Naze, *c.* 1912

In 1834 another entrepreneur, John Warner, the Quaker businessman, built East Terrace, a terrace of seven houses with a reading room and bazaar. The grand house at the end, which is prominent on many photographs of the seafront, was his residence. Later, it became the Eastcliff Hotel. Until 1921, Warner had an iron foundry and dock connected to the Walton Channel. Robert Warner, his son, paid for three breakwaters opposite the East Terrace as well as the promenade and sea walls on that part of the front.

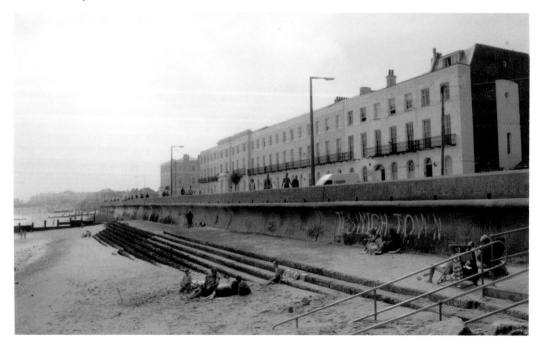

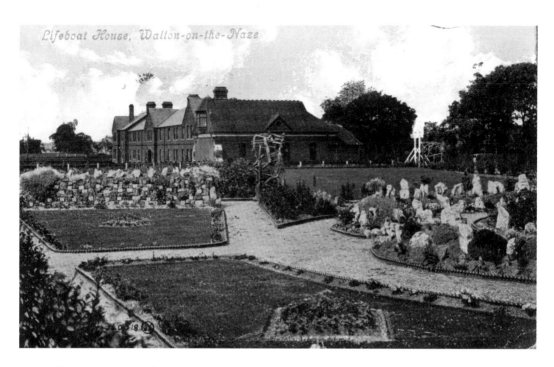

Lifeboat House, Walton-on-the-Naze

Lifeboat House, Walton-on-the-Naze, *c.* 1910

The Lifeboat House was built in 1884, originally housing a self-righting lifeboat – *Honourable Artillery Company*. There was a slipway opposite for launching and recovering the boat, but it still meant hauling it across the sand at low tide. In 1900, the new lifeboat was moored near the pier head, where the new lifeboat is stationed today. The Lifeboat House is now a fascinating Maritime Museum.

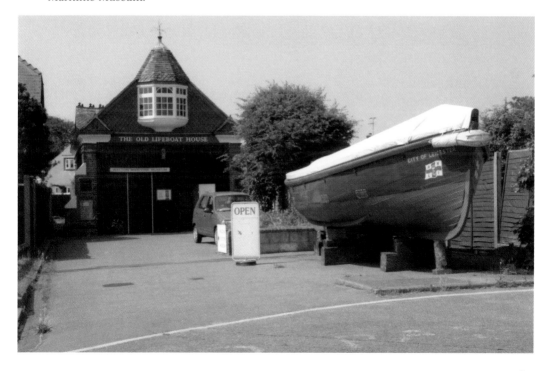

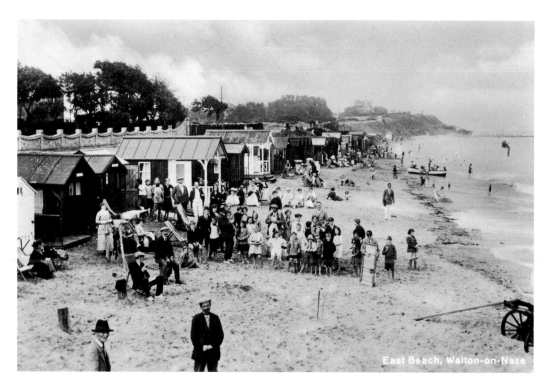

East Beach, Walton-on-the-Naze
Two wonderful photographs, both undated, although they look as if they might be the 1920s, showing the beach close to the Lifeboat House. A wonderful assortment of huts and tents line the edge of the sand.

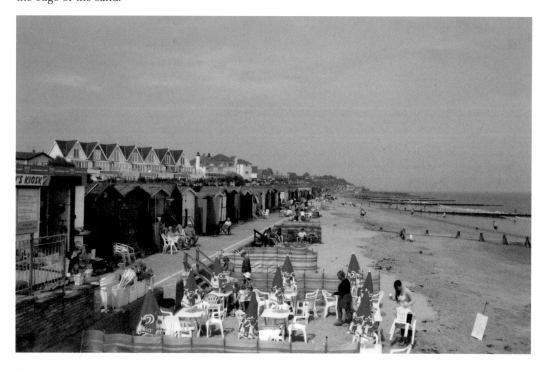

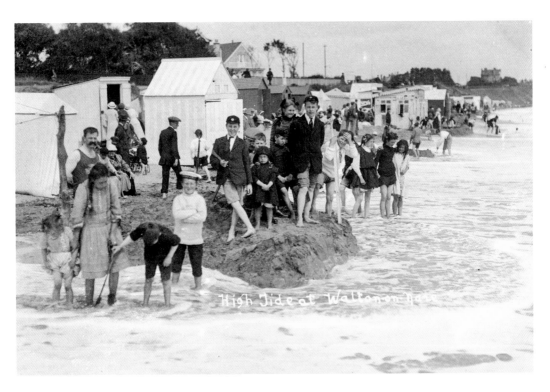

High Tide at Walton-on-the-Naze
Today there is a small beach shop and restaurant and the rows of beach huts now line a concrete promenade that stretches the whole length of the beach.

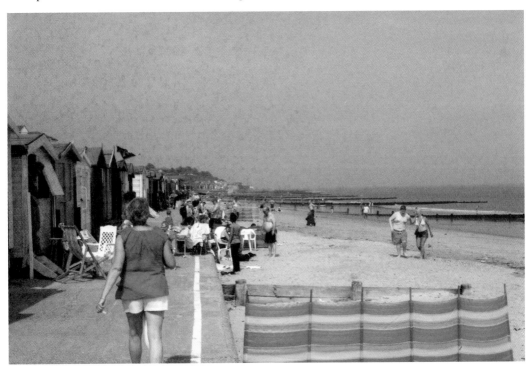

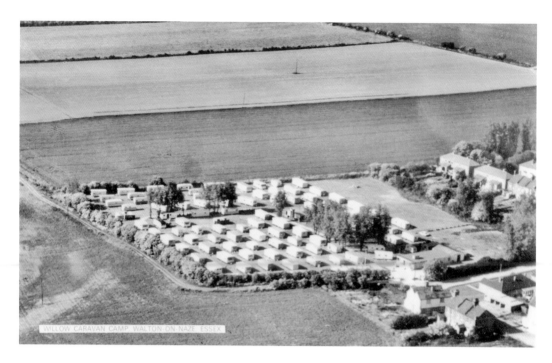

Willow Caravan Camp, Walton-on-the-Naze

The great hotels have nearly all gone now, but there are still the caravan parks for those who want a less expensive holiday or own a van on a site to visit when it pleases. The family-run Willows Caravan Park is one such and there is the larger Naze Marine Holiday Park, boasting an indoor pool and clubhouse with entertainment, as well as the Martello Park. And you're right, you won't find a caravan park in Frinton.

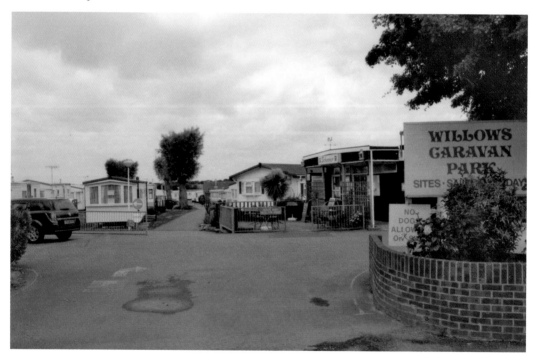

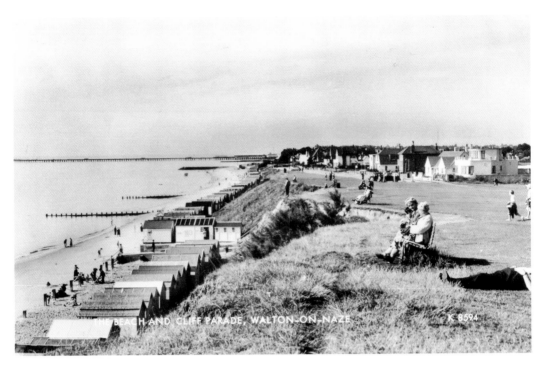

The Beach and Cliff Parade, Walton-on-the-Naze, *c.* 1960

'We are enjoying it very much here and kiddies are tickled pink with the caravan. It rained hard Whit Monday evening and we had one short shower yesterday otherwise it has been lovely, until this morning and at the moment (7.10 a.m. all others are fast asleep) it is raining hard. The kiddies love the pier funfair and merry-go-rounds galore, where the money goes...'

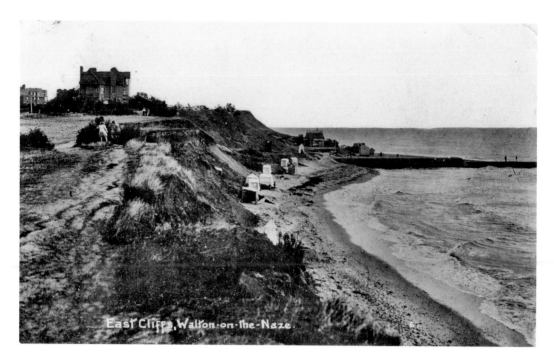

East Cliffs, Walton-on-the-Naze, *c.* 1912

In the 1880s Philip Brannon began an adventurous project for Naze Park close to the Naze Tower. Naze Park Road was constructed and, in 1882, he built an impressive house on the cliffs called Highcliff Mansion. The Naze Park venture was a failure and, in 1886, the house became St Osyth's Home of Rest for the Work Girls' Protection Society. By 1901 it was St Osyth, House College and in the 1920s the Mabel Greville Convalescent Home. It was demolished in 1984.

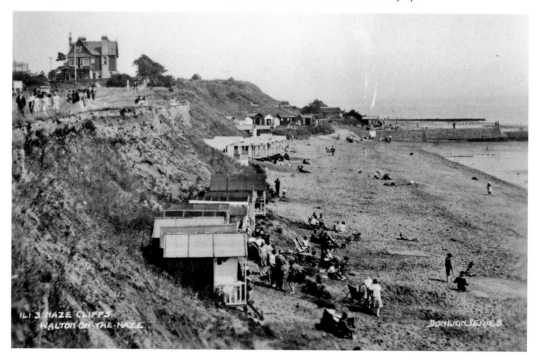

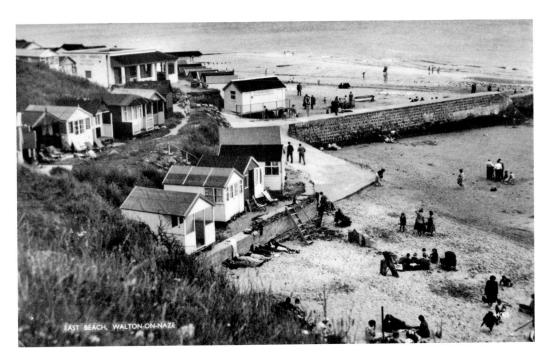

East Beach, Walton-on-the-Naze, *c.* 1959

Hipkin's Beach is a popular spot with its small café. It is privately owned but open to the public. It is sufficiently far from the pier and centre of Walton to not become too crowded. The Mabel Greville name stayed on as the name for the groyne at Hipkin's Beach below the old house. The groyne itself was severely damaged by heavy seas on 23/24 December 2012 and as a result was much shortened.

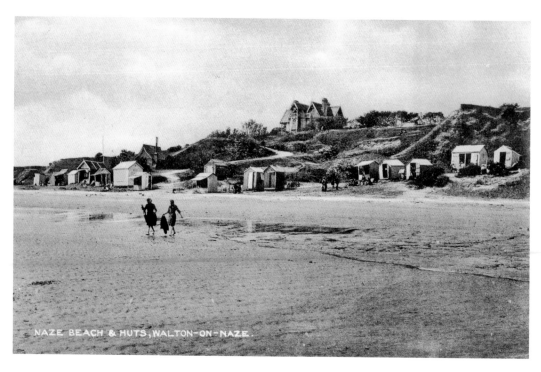

NAZE BEACH & HUTS, WALTON-ON-NAZE.

Naze Beach, Walton-on-the-Naze, *c.* 1910
It might have been different if the Naze Park project had been successful, but this photograph has rather a bleak look to it, which is greatly enlivened today by the colourful beach huts sitting on the promenade behind the sea wall.

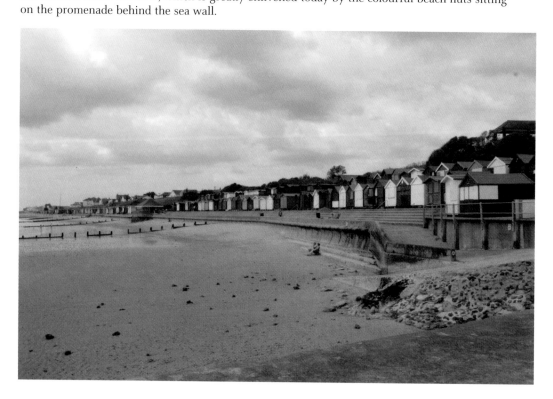

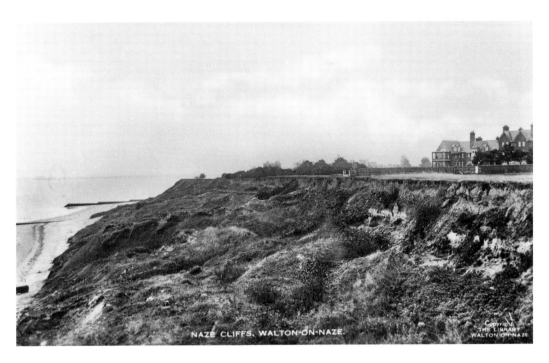

Naze Cliff, Walton-on-the-Naze, *c.* 1937

The old Highcliff mansion can just be seen in the distance. On the right is the Samuel Lewis Convalescent Home on a very exposed part of the crumbling Naze. This is the classic place on the East Anglian coast where parties of geography students are brought to study coastal erosion. While we were there a group of students were exploring the new granite sea defences being constructed.

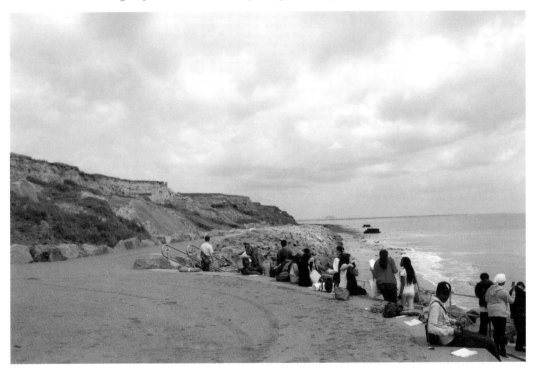

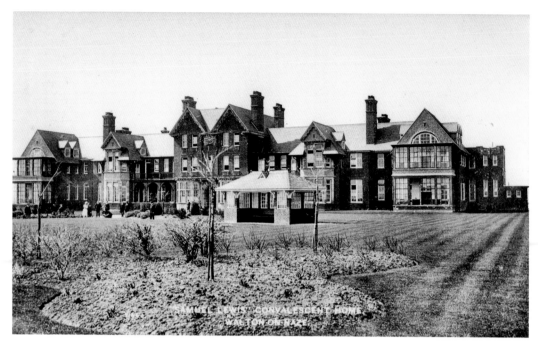

Samuel Lewis Convalescent Home, Walton-on-the-Naze, *c.* 1920

Samuel Lewis (1837–1901) was a moneylender and philanthropist. He was reputed to be one of the richest men in England and when he died his widow Ada carried on spending money for the benefit of others. The home was built in 1910 and run by the Jewish Welfare Board. In its time it housed Kindertransport children evacuated from Europe between 1938 and 1939. It was used as a billet for soldiers during the Second World War. Eventually, as the edge of the cliffs crept nearer, it was closed in 1976 and demolished soon after.

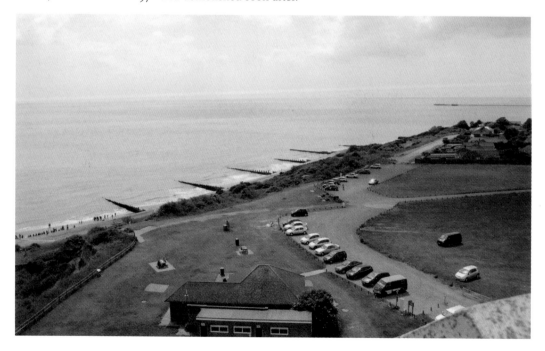

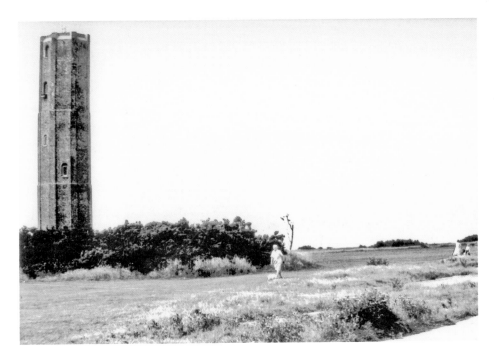

Naze Tower, *c.* 1980

One of the earliest landmarks on the Naze was the 86-foot-high Naze Tower, built by Trinity House in 1720 as a navigational aid for mariners. It has been put to many uses over the years by the Coastguard and the Royal Navy. The Royal Air Force used it during the Second World War when a radar scanner was fitted on top. After several years unused it reopened in 2004 after extensive restoration as a café, art gallery and, for those prepared to climb the spiral staircases up the eight floors, a platform to enjoy the most glorious views.

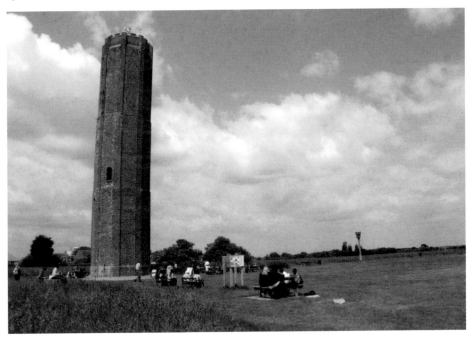

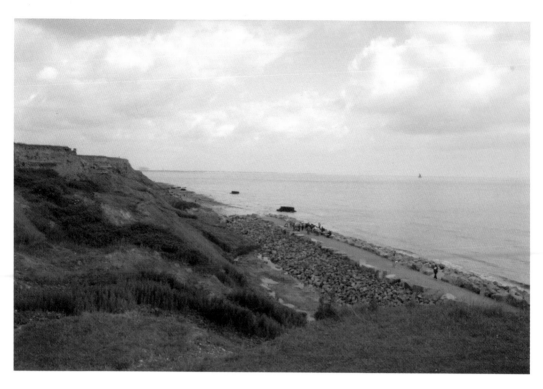

The Naze, 2013

Some 400 yards of cliff have been lost here, but if these new defences work the iconic tower, which has been used as a symbol for Walton-on-the-Naze for so many years, may yet stand for many more years to come.

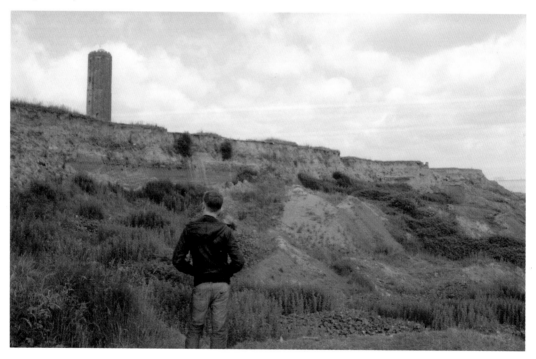